# ERNEST HEMINGWAY
# & GARY COOPER
## IN IDAHO

*An Enduring Friendship*

**LARRY E. MORRIS**

THE
History
PRESS

Published by The History Press
Charleston, SC
www.historypress.net

Copyright © 2017 by Larry E. Morris
All rights reserved

First published 2017

Manufactured in the United States

ISBN 9781467137188

Library of Congress Control Number: 2017940945

*"Loving some one…is the most important thing
that can happen to a human being."*

—*Ernest Hemingway*, For Whom the Bell Tolls

# CONTENTS

# ACKNOWLEDGEMENTS

My thanks go to the following individuals and institutions: Mary Tyson, the Community Library Regional History Department, Ketchum, Idaho; Rachel Phillips, Gallatin History Museum, Bozeman, Montana; Lory Morrow and Kendra Newhall, Montana Historical Society, Helena, Montana; Connor Anderson and Laurie Austin, John F. Kennedy Presidential Library, Boston; Stephen Ferguson, Brianna Cregle and AnnaLee Pauls, Princeton University Library, Princeton, New Jersey; and the staff at Brigham Young University's Harold B. Lee Library, Provo, Utah, where I spent countless hours and found virtually every book I needed.

Thanks are also due to the researchers and writers, both past and present, whose work was so valuable in my own research, particularly Carlos Baker, Jeffery Meyers, Brewster Chamberlin, Ruth A. Hawkins, Bernice Kert, Michael Reynolds, James M. Hutchisson and Paul Hendrickson, as well as to John Mulholland, writer and director of the documentary *Cooper and Hemingway: The True Gen*, a valuable resource and always a joy to watch.

On a summer night in 1970, at the Atomic City Hilton on the Idaho desert, my friends Bob Schoch, Bruce Didesch and John Long and I were talking when John mentioned a book he had read but I had never heard of: *Papa Hemingway*. Based on his recommendation, I read the book, a memorable experience that laid the foundation for serious research of Hem and Coop forty-five years later. Thanks, Ling.

A book like this needs a good map—I am indebted to Blake Gulbransen for producing an excellent one.

It is a pleasure to work with the editors at The History Press, and I am especially grateful for the help of Artie Crisp and Ryan Finn.

My special thanks to Maria Cooper Janis for her kindness and encouragement.

I am thankful to my sister, Lorraine, and my brother, Kent, for their interest in my work and for their lifelong friendship.

As always, I tremendously appreciate the love and support of my wife, Deborah, and our children and their spouses—Whitney, Justin and Jen, Courtney and Adam and Isaac and Tahlia. Among the nine of us, we have read quite a variety of Hemingway books and seen quite a variety of Cooper films. Our combined experience also includes several visits to Hem's burial site (and Pound's birthplace) in central Idaho, driving all of Highway 93 between Missoula and Ketchum (a key part of the route of Hem's last journey) and even reading *A Moveable Feast* in Paris.

# "BEST OF ALL HE LOVED THE FALL"

On the afternoon of Tuesday, September 1, 1939, forty-year-old Ernest Hemingway drove his black Buick Special two-door convertible along Yellowstone Lake to Fishing Bridge and then descended the meandering Yellowstone River through the meadows, groves, rolling hills—and bison herds—of Hayden Valley. The serene Yellowstone Park setting offered a stark contrast to the news reports he had been listening to on his car radio: the German *Luftwaffe*, supported by battleships and infantry, had launched a massive invasion of Poland.

"Hem," as several friends called him, had driven from Key West, Florida, to hunt and fish with his three sons—Jack, fifteen; Patrick, eleven; and Gregory, seven. First he was scheduled to pick up Jack, staying at Holm Lodge, a dude ranch west of Cody, Wyoming, with his mother, Hadley Richardson (Hemingway's first wife), and her husband of six years, Pulitzer Prize–winning journalist Paul Scott Mowrer. When Hem discovered that they were fishing at Grebe Lake, he went in search of them. Near Canyon Village, he followed a gravel fire road that got him within two miles of the lake. He parked his car next to another that presumably belonged to Paul, got out and started up the trail. Not long after that, as he rounded a stand of lodgepole pines, he came face to face with Hadley and Paul, who were surprised but delighted to see him. Hem had known Paul in Europe in the 1920s and liked him. Not only that, but he could also see that Hadley was happy. He would later write to her that she and Paul made a fine-looking pair on the trail.[1]

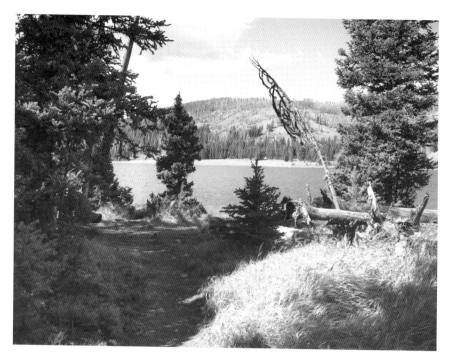

Grebe Lake, Yellowstone National Park, where Hemingway saw Jack, Hadley and Paul Mowrer in 1939. *Photo by Tim Angeli, 2009.*

Hadley had been devastated by Hem's divorce in 1927 and had not seen him for eight years, but this was a memorable and congenial reunion. Hadley, now forty-seven, had gained weight but looked healthy and attractive, her hair still red and her face unlined. Hem, by contrast, had aged considerably, with his weight gain accompanied by graying hair and a countenance that reflected such ailments as high blood pressure, blurred vision and the effects of heavy drinking.[2]

As Hem, Hadley and Paul updated one another on recent events, Jack, who had lingered at the lake long enough to catch a few more Arctic grayling, came up the path. "I was delighted by the sight of Papa, Paul, and Mother sitting on the edge of the trail talking animatedly," he wrote almost fifty years later. By that time, the conversation had turned to events in Europe, with Hem and Paul both convinced that a long war and U.S. involvement were both inevitable. "It was wonderful for me to see my mother, my father, and Paul all together talking like that," added Jack. "This was the first time since the Paris days that they had been together, and, as it turned out, it was the last time ever."[3]

The four of them continued their conversation as they returned to the cars. Then, after bidding farewell to Hadley and Paul, Hem and Jack went north and east to a Wyoming ranch called the L-Bar-T, frequented by the Hemingway family throughout the 1930s. A day or two later, Toby Bruce, a jack-of-all-trades employee of Hem's, arrived with Patrick and Gregory, who had spent the last two months at a camp in Connecticut while their mother—and Hem's estranged wife, Pauline Pfeiffer—toured France, Switzerland and Austria with a friend.

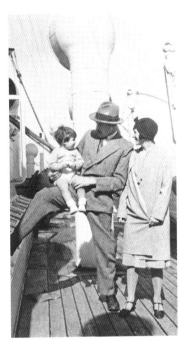

Ernest Hemingway, Pauline Pfeiffer Hemingway and Patrick Hemingway onboard a ship, 1929. *Princeton University Library.*

Hem and the boys had barely settled in when Pauline called from New York and said she wanted to join them at the L-Bar-T. Hem was surprised—that had not been part of the plan. For the past two years, he and Pauline had spent less and less time together, teetering on the edge of permanent separation. Pinpointing the genesis of their falling-out was hardly difficult.

It had all started on a December 1935 evening in Key West, when Hem had been late coming home for dinner with Pauline and friends Charles and Lorine Thompson. When Hem didn't show, Charles walked over to Sloppy Joe's Bar to find him but returned alone. "He's talking to a beautiful blonde in a black dress," Charles announced.[4]

The beautiful blonde was a twenty-seven-year-old woman who counted Eleanor Roosevelt among her friends and was on her way to becoming one of the most renowned war correspondents of the twentieth century: Martha Gellhorn. "It is extremely pretentious to take the world's troubles as your own," she would write to a friend in 1940, "but I must say they concern me more than anything else."[5]

Martha and Hem began an affair early in 1937 while they were both covering the Spanish civil war. Ever since then, Hem had found frequent excuses to be away from his and Pauline's Key West home, and Pauline knew that he was spending those times with Martha. In a letter written from Europe just three weeks earlier, she had described her recent travels

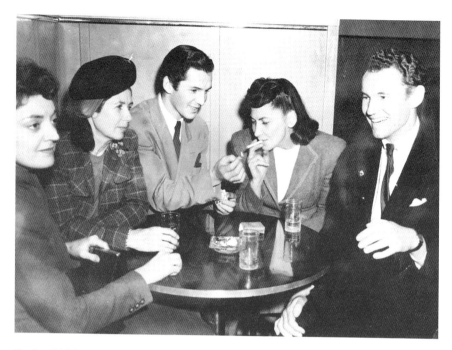

Pauline Pfeiffer Hemingway, *second from left*, with friends, late 1940s. *Princeton University Library.*

and then lashed out, "Oh, Papa darling, what is the matter with you. If you are no longer the man I used to know get the hell out, but if you are, stop being so *stupid*."[6]

Pauline arrived with a bad cold, however, and was too sick to hunt or fish or do anything else with the family. Hem cooked her meals and tried to take good care of her, but the drafty cabin made her cold worse. Not only that, wrote Pauline's biographer, "but Pauline seemed to him like a stranger who had intruded on his vacation with his sons."[7]

The fall hunt Hem had been anticipating—and that Pauline hoped would help mend the rift between them—did not materialize. Instead, the final dissolution of their relationship became increasingly evident. Patrick recalled that when Pauline finally felt well enough to unpack her clothes, she found that the plastic buttons on a favorite suit had melted through the fabric. She broke down and wept while Patrick tried to comfort her. To him, it was the "knock-out punch," and Hem, who had clearly chafed at Pauline's unplanned presence, decided that he had seen enough. He told Toby to take Pauline and the boys to Arkansas and from there to Key West.[8]

By the time Pauline departed with Patrick and Gregory, she had decided she could no longer tolerate Hem's splitting his time between his mistress and his faithful wife. Hem also made a decision: he called "Marty" Gellhorn in St. Louis and asked her to fly into Billings. On Tuesday morning, September 19, with Marty sitting beside him and the car loaded with camping, fishing and hunting gear and guns, ammunition and books, Hem drove the Buick west from Billings toward West Yellowstone. Ten miles beyond "West," he and Marty crossed the Continental Divide at 7,072-foot Targhee Pass and entered Idaho for the first time, an apt symbol for their new life.

It was a perfect September day, warm and clear, and Hem and Marty took in the sudden deep blue of a mountain lake, then a valley lined with meadows, marshes and shallow streams perfect for fly fishing. They descended Henrys Fork of the Snake River and then caught a view of the spectacular Teton Range to the east. Before them lay the farm country of the Upper Snake River Valley.

They stopped for a drink in Idaho Falls, a town of some fifteen thousand people that straddled the Snake River. It was early evening, they had another

Targhee Pass, along the Continental Divide, where Hemingway and Martha Gellhorn entered Idaho for the first time. *Photo by the author, 2016.*

Hemingway and Martha saw Henrys Lake (*top*) and Henrys Fork (*bottom*) as they descended Idaho's Upper Snake River Valley. *Photos by the author, 2016.*

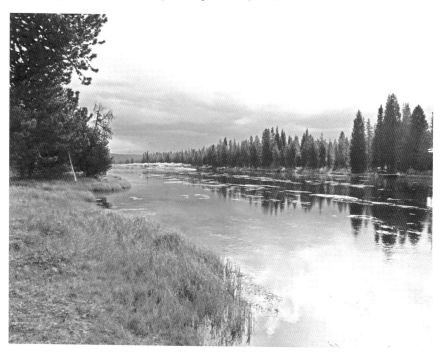

170 miles to go and Hem had likely been warned that there were stretches of gravel road ahead.

A week later, the *Idaho Falls Post Register* ran a story announcing "Hemingway Takes Room in Empty Sun Valley Lodge." Not mentioning Marty, the piece noted that Hemingway would have absolute quiet while he worked on a new book for the next six weeks. "The writer of '*A Farewell to Arms*' and other novels," continued the article, "had made special arrangements to occupy one of the 200 rooms at this resort center until the winter season opens."

The Associated Press story concluded with a mere afterthought that would turn out to be a profound portent of the last two decades of Ernest Hemingway's life: "Hemingway said he might be joined later by movie star Gary Cooper for a fishing and hunting trip."[9]

On the morning of September 20, thirty-three-year-old Lloyd Arnold, a Union Pacific employee assigned to photograph and promote Sun Valley as a yearlong vacation spot, was riding a horse near the resort hotel when he crossed the path of "a big man and a tall attractive blond girl" he hadn't met, although the man "had a familiar look." When Lloyd lifted his hand in a friendly salute, the man—who wore jeans, boots and a leather-fringed hunting vest over a light shirt with rolled-up sleeves—grinned and returned the salute, "snapping it off briskly as a sharp soldier would." *None other than Ernest Hemingway*, concluded Lloyd, who returned Hem's smile but said nothing.[10]

From Idaho Falls, Hem and Marty had followed Highway 191 southwest to Blackfoot and then Highway 27 northwest across the sagebrush-covered Snake River Plain, a desolate stretch of terrain that Hem immediately liked because the mountains to the north reminded him of Spain. It was dark by the time they reached the lonesome hamlet of Arco, where virtually all of the five-hundred-odd residents looked to be fast asleep. (Sixteen years later, Arco would become the first community in the world to be lit by nuclear-powered electricity.) Hem, no doubt relying more and more on a map, next went southwest on a road—hardly a highway—numbered 22, his headlights lonely in the darkness, and soon he hit the gravel roads he had been warned about. Not long after that, he and Marty found themselves in the remote volcanic lava fields known as Craters of the Moon. The area had its own stark beauty during the day, but at night, said Hem, "it was like something out of Dante's Inferno." He was ready to turn back and return to Idaho Falls "for a few stiff ones" and say "to hell with the great Sun Valley," but he forged on, concluding that there must be something special about Sun Valley if it was this hard to get to.[11]

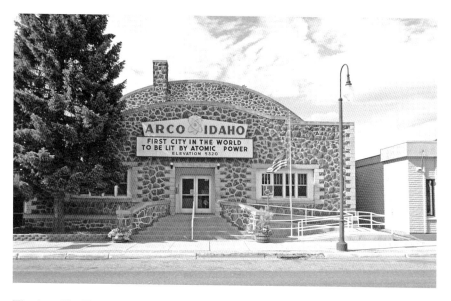

The Arco City Hall proclaims the town's claim to fame. *Photo by the author, 2016.*

They drove on and on, not seeing the lights of another car or even a farmhouse for mile after mile. The towns of Carey, smaller than Acro, and Picabo, smaller than Carey, were welcome sights but especially the wide and well-paved Highway 93 leading to Hailey, the largest town they had seen in almost three hours. The mining town of Ketchum and the Sun Valley resort (a mile or so northeast of Ketchum) were now only fifteen miles away, and at the Sun Valley Lodge, they were welcomed by the resort's general manager, Pat Rogers. Pat escorted them to one of the best suites in the lodge, no. 206, which included two bedrooms—each with its own balcony and bathroom—and a living room also with a balcony and, as they would learn the next morning, a striking view of 9,150-foot Mount Baldy.

Not one to sleep in despite the late arrival, Hem woke Marty the next morning, and not long after seeing Lloyd Arnold, they were enjoying breakfast at the nearby Challenger Inn. Lloyd had told his wife, Tillie, about seeing Hemingway and then met up with Sun Valley publicist Gene Van Guilder, who had already heard the news. A native of Twin Falls, Idaho, thirty-seven-year-old Gene had the perfect skill set to promote the resort—he could write and edit his own press releases, he was a skilled outdoorsman and he was great with people. He had already entertained several celebrities at Sun Valley and the publicity had been good, but management was hoping to attract tourists throughout the year. In 1938,

when the New York office learned that Hemingway spent time near Cooke City, Montana, each year, a staffer was sent to Key West with a proposition: the resort would provide Hem and his guests with complimentary lodging and meals for two seasons if he would allow his visits to be publicized. He expressed interest but was too involved in covering the Spanish civil war to immediately consider the offer. Still, he promised to keep it in mind.

When Gene called New York with the news that Hemingway and a lady friend had arrived, he was instructed to roll out the red carpet but to do so gently because the famous writer "spooks easily." Now Gene and Lloyd waited in the Challenger Inn lobby for Hemingway and his companion—both knew this woman was not his wife—to finish their breakfast. When the maître d' gave a signal, the two men approached the table at the far end of the otherwise empty dining room and introduced themselves. Hem, who had eyed them suspiciously the entire time, rose, apologized for arriving so late the previous night and introduced "Miss Gill." Lloyd wrote that Martha was "perfectly at ease" and "wore as infectiously pretty a smile as [he'd] seen in some time."

After an awkward moment, Martha reminded Hem to invite their guests to sit down. "Of course," said Hem, grinning and motioning with his hand. Doing away with formalities, Hem asked Gene and Lloyd not to call him "Mister," referring to himself as "old Ernie" and Martha as "Marty." At Marty's prompting, Hem acknowledged that his sons called him "Papa," a habit many of his friends had also adopted. Next, with a characteristic touch that would endear him to a host of Idaho residents soon to consider him a friend, Hem began asking Gene and Lloyd about their backgrounds, showing an engaging interest that was undoubtedly genuine. Hem knew he was in sheep country, with Basque sheepherders scattered throughout the region, and mentioned his great affection for the Basque area straddling the border of France and Spain. Soon Hem and Gene were surprising Marty and Lloyd by conversing first in Spanish and then in the difficult Basque tongue.[12]

Although Gene and Lloyd were convinced they had made a lifelong friend, Tillie, Lloyd's pert and likeable thirty-four-year-old wife who ran the resort camera shop, needed more convincing. When Hem called Lloyd the next morning and invited him and Tillie to breakfast, Tillie was less than enthusiastic. She had already met a number of celebrities at Sun Valley and had not been too impressed with some of them. Still, she wanted to support Lloyd, and she was also curious about what kind of man Ernest Hemingway was.

It didn't take long to find out. Minutes after Lloyd and Tillie sat down with Hem and Marty, the four of them had clearly entered into what Tillie described as a "laughing, joking, kidding, teasing, friendly, loving relationship." Tillie found Hem to be unassuming and personable, a captivating teller of stories who frequently pointed at his eyebrow when talking about himself and often hesitated as he talked as if struggling to get the words out. Marty was witty, intelligent and spontaneous, her smile contagious. By the time the waitresses began preparing to serve lunch, the four new friends had talked about Lloyd's and Tillie's early lives in the Midwest; how Tillie, whose given name was Erma, got her nickname; and about Marty's youth in St. Louis and Hem's in Chicago and Michigan.

"I need to make some purchases for our room," said Hem. "Would you like to come up later to 206 and share the bounty?" Lloyd said yes without hesitating, and Tillie agreed, convinced that they would be spending time with friends, not catering to celebrities. She felt quite comfortable with the man who was already calling her "daughter" but couldn't have guessed that over the next twenty years she would become one of his most trusted friends.

Lloyd and Tillie soon learned of the novel that Hem was writing about the Spanish civil war. He told Lloyd he had twelve chapters done but that it would be a long book. He also felt that the fall weather in Idaho was invigorating, perfect for writing. In fact, Hem added a few days later, he was so pleased with Idaho that he had specifically mentioned Sun Valley in chapter 13 of the book.[13]

Hem was hoping to write in the mornings and frequently hunt in the afternoons. Lloyd and Gene had been glad to hear during their first meeting with Hem that he was more interested in hunting quail, mourning doves, chukars, pheasants, partridges and mallards with a shotgun than either fishing or big-game hunting. That was perfect because the Snake River Plain offered exceptionally good bird hunting. The name of Taylor "Beartracks" Williams, Sun Valley's chief guide, naturally came up. A fifty-three-year-old Kentuckian who had lived in Idaho for many years, Taylor was an expert fisherman and hunter who had reportedly invented the Renegade dry fly. He was well read, witty and easygoing. Hem smiled and said that Taylor sounded like a real character. He was not disappointed when he met Taylor, who returned from guiding a fishing party a few days later.

Hem consistently worked on his novel from dawn until early afternoon. After that, he and Marty spent their afternoons with Lloyd, Tillie, Gene and Taylor, or some combination thereof, occasionally horse riding and

trap shooting but more often playing tennis or exploring Silver Creek, a picturesque and peaceful spring-fed stream that ran through the meadows, marshes and fields near Picabo (fifty miles south of Sun Valley) and attracted an amazing variety of birds and waterfowl, as well as coyotes, bobcats, deer and elk and, now and then, a mountain lion. Silver Creek would become Hem's favorite hunting spot in Idaho.

The typical evening routine included group dinners followed by socializing—and alcohol, of course—at "Glamor House," Hem's nickname for suite 206. Taylor, by now called "Colonel" by Hem, quickly became known among the group for his mint juleps. Hem often fixed drinks for the entire party, stirring his own scotch and water with his finger. "From the very beginning," wrote Tom Dardis, Hemingway had "found that drinking sharpened life for him like nothing else, perhaps even made it meaningful; life without it was flat and dull." At the same time, neither Tillie nor any other Idaho friends felt that Hem's drinking was excessive, but this was true because Hem had put himself "back in training" to complete his novel, significantly reducing his near-constant drinking in Spain.[14]

Tillie wrote that Hem took unique pleasure in long, animated conversations, sometimes telling stories of his own but more often than not asking questions of others, listening, pondering, asking more questions and showing an extraordinary interest in the experiences and thoughts of his dinner companions. When asked about his childhood, Hem said that his father was a doctor and his mother both a talented singer and piano player. But he frowned as he recalled his mother forcing music on her children. He described his father as a wonderful but cowardly man who put up with his wife's dominating ways. When he called his mother a bitch, Tillie protested, but Hem said, "Daughter, it is true, and I'm sorry, but I say it even at the risk of losing your friendship." A moment later, Hem put his arm around her and apologized for bursting out with such a statement.

Hem told the details of his father's 1928 suicide and how it was a cowardly thing to do. Still, he blamed his mother for his father's death because she was so domineering. Like other friends, Tillie and Lloyd would learn that suicide was never far from Hem's mind. He also talked freely about his three sons and his marriages to Hadley and Pauline. He spoke of Hadley in such glowing terms that Tillie and Lloyd were both convinced that his marriage to Pauline had been a mistake. He was divorcing Pauline, he said, but she was stalling, hoping to save the marriage.

Hem enjoyed seeing the country surrounding Sun Valley and took a particular liking to Al Lewis's Snug Bar in Hailey, where the group always

stopped after trips to Silver Creek or Shoshone. Lewis had assembled a Hailey museum of sorts that he kept in a back room, and one day Hem was browsing the artifacts when he discovered to his delight that the famous—and infamous—poet Ezra Pound had been born in Hailey. Growing serious, Hem explained how Pound, thirteen years his senior, had been his mentor, friend and benefactor during the Paris years, making it clear that he would always feel indebted to the controversial poet.

The October 2 issue of the *Post Register* offered a good clue about Hem's autumn activities. "Hemingway Second in Shoot," announced the headline, with the body of the article explaining: "Ernest Hemingway, well-known American author, came off second best here in the Sun Valley Pistol club's shoot for hunters." Never one to enjoy finishing second, Hem found consolation in losing to a good friend and crack shot. "Using a big-game rifle," continued the piece, "Hemingway placed second to Gene Van Guilder of Sun Valley in the off-hand standing shooting event at the 100-yard distance."[15]

The birthplace of Ezra Pound, Hailey, Idaho. *Photo by the author, 2016.*

Gene was also busy preparing for a "potlatch dinner" to be held on Armistice Day, November 11, where news people throughout southern Idaho would feast on various wild game dishes while learning more about Sun Valley. From the first time he heard of the event, Hem had encouraged Gene to "wine 'em and dine 'em" in grand fashion. One night at Glamor House, Gene wondered aloud if they could get "Coop"—Gary Cooper— to attend the event. Coop could get in some good pheasant hunting, said Gene. Besides, Coop needed to meet "this big guy," he said, referring to Hem. Gene next suggested that the four of them write a letter "in quad," informing Coop of Hem's presence and inviting him to the dinner and a few days of hunting. Hem loved the idea and said that Coop owed him a few beers for making at least a small contribution to Coop's career (because Coop had starred with Helen Hayes in *A Farewell to Arms*, a movie based on Hem's book). All four men signed the letter, and Hem's note read, "It looks like a good booking up here; try and get a piece of it with us. E.H."

One week later, the group was having dinner at the Ram restaurant when Gene got a phone call. It was Coop. He had received the letter, he said, but was sorry he couldn't make it because he was in the middle of filming a movie. The phone was passed to Taylor and then to Lloyd and finally to Hem, who took it enthusiastically. The renowned writer and renowned actor thus "met" for the first time through a phone conversation. They spoke for several minutes, with Coop doing most of the talking, not surprising given Hem's natural shyness and his longtime aversion to telephone calls. But he obviously liked what he heard, saying that Coop "sure unwinds with the talk once he gets going."[16]

Coop had called from the Sonoran Desert in Arizona, where he was filming *The Westerner*, a movie set in 1880s Texas, with Coop's friend Walter Brennan playing the notorious Judge Roy Bean, a historical figure who held court in his saloon and called himself the "Law West of the Pecos." Coop initially objected to his role as the fictional Cole Harden, a suspected horse thief hauled into Bean's "courtroom," claiming that playing second fiddle to Brennan's Bean would jeopardize his professional standing. The studio insisted, reminding Coop of the terms of his contract, and he eventually agreed "to perform my services…to the fullest of my ability, with the express understanding that I am doing so under protest." The finished film, however, left no doubt that Coop was the leading man. Screenwriter Niven Busch described an added benefit of having Coop on the set: "If I was stuck [on the script] I ran down to Cooper's dressing room, and he would put me right. Cooper was such a fund of information about the West."[17]

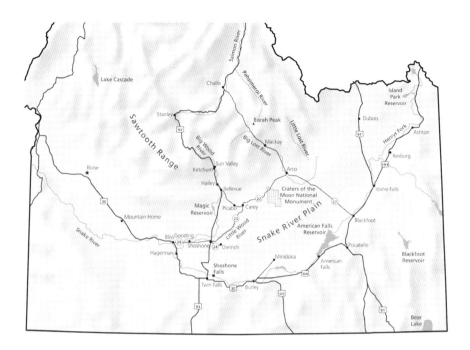

Southern Idaho and its main highways in 1940. *Map by Blake Gulbransen, Lee Library, Brigham Young University.*

When duck season opened, Gene proposed a two-day excursion to the Thousand Springs area of the Snake River near Hagerman, where the group could hunt ducks in the morning and pheasants in the afternoon and ensure a well-stocked pantry for the potlatch festivities. Hem, who loved the dual-hunting plan and wanted to see the springs cascading out of the volcanic wall of the Snake, enthusiastically voted in favor of the idea. He also said they should add a picnic to the itinerary. The weekend of Saturday and Sunday, October 28–29, would be the perfect time.

As that weekend approached, however, Hem bowed out of the duck hunt because his writing was going so well. On the afternoon of Friday, October 27, quite likely after telling Hem and Marty they would see them on Monday, Gene and his wife, Nin; Nin's four-year-old daughter, Cindy; and a friend by the name of Dave Benner loaded up Gene's Chevrolet Carryall Suburban, along with a trailer and canoe, and departed Ketchum, with Lloyd and Tillie following in their car. The sixsome put up for the night in some rented cabins, and Gene, Lloyd and Dave hunted all the next day from the canoe but didn't do too well. Concluding that he needed more ducks for the dinner,

Gene decided on another morning of hunting. Saturday night was a magical autumn evening, recalled Tillie, and with no one else staying in the cabins, they enjoyed the privacy, cooking hamburgers and sitting by the river while they talked. Lloyd, Tillie and Dave took care of Cindy as Gene and Nin took a long walk along the Snake.

Early Sunday morning, Gene, Lloyd and Dave loaded their shotguns and ammunition into the canoe and paddled away. They were scheduled to return by noon, so Tillie and Nin had the cars packed up and ready by then. When the hunters did not appear, Tillie and Nin assumed that the hunting must be good and walked with Cindy down to the river to listen for gunshots. Hearing nothing, they returned to the cabins to wait. After a while, they went back to the river, by now worrying and wondering if something had happened. They had returned again to the cabins when a car they didn't recognize pulled up. It was Dave, pale and frantic. He rushed from the car and told Nin to come with him. There had been an accident. "Oh, I knew something was wrong," moaned Nin.

Stunned and not knowing exactly what had happened, Tillie sat with Cindy for a few minutes. Then she took Cindy to the cabin owners, who agreed to watch her. Tillie next got in her car and drove downriver, in the direction Dave had driven. She had not gone far when she saw the car parked near a farmhouse. Lloyd came to the car to meet her, his grim expression hinting at what she feared: "Gene is dead," he said.[18]

Around noon, with Gene and Lloyd hunting in the canoe and Dave scouting an island for pheasants, Gene had suggested that it was time to pack up and leave. Lloyd, who had had most of the good hunting that morning, wanted to give Gene another chance and said they might see some good ducks on the way to pick up Dave. Lloyd volunteered to paddle while Gene continued hunting. As they picked Dave up and headed back across the river, Gene saw several ducks in a cove. Thinking they were pintails, the best ducks for eating, Gene asked Lloyd to paddle toward them. Lloyd paddled closer and then stuck his paddle in the mud to steady the canoe. As if on cue, a raft of ducks rose into the air and two shots rang out—Gene firing both barrels of his twelve-gauge, assumed Lloyd, who saw six ducks go down. Lloyd started to say something about the ducks but was cut off by the lurching of the canoe, the boom of another shot and Gene toppling into the hull of the boat.

Gene had been hit below his right shoulder, the blood flowing fast. Lloyd tore off his shirt and then his undershirt, stuffing it into the wound and urging Gene to hang on, knowing all the while that the gunshot was fatal.

Dave got the canoe to shore and then ran for a group of men some distance downstream. As Lloyd waited an "eternity" for help, he did everything he could to save his close friend. "I've never ceased to wonder at the courage and honesty in the remarkable man who was Gene Van Guilder," Lloyd wrote almost thirty years later. "He had a number of things to say, and we managed them all….[His death] came quietly—in the shade of the little farmyard." Gene made several requests of Lloyd, which Lloyd did his best to fulfill, but he never told Tillie the specifics.

Gene lived for about thirty minutes after being wounded but was gone by the time Nin arrived. Tillie found her walking around the farmyard in shock and tried to comfort her while Lloyd called the Gooding County sheriff and coroner. Next he called the Sun Valley Lodge; Pat Rogers was away from his office, so Lloyd gave the bad news to Flo Riley, Pat's secretary.[19]

The county seat of Gooding was thirteen miles away, and the officials came as fast as they could, but it seemed like another eternity to Lloyd and Tillie. Luckily, both the sheriff, Wayne Flack, and the coroner, James W. Creed, knew Gene well, and they handled discussions with Nin and interviews with Lloyd and Dave with delicacy. The conclusion of the investigation was reported by the Associated Press and reprinted in newspapers throughout the western United States:

> HAGERMAN, Idaho, Oct. 30.—Coroner James W. Creed said Gene Van Guilder, director of publicity for the Sun Valley, Idaho, resort, was killed on the Snake River yesterday by the accidental discharge in the hands of a duck hunting companion.
>
> Dave Benner, of Sun Valley, and Lloyd R. Arnold, chief photographer at the resort, were with Van Guilder, who was standing in the bow of their canoe, both shot to flush some ducks from a blind.
>
> The boat lurched with the shots, and Benner's gun again discharged, he said, firing a load of buckshot into Van Guilder's chest and lungs.
>
> Survivors include his widow and his father, Harry Van Guilder, of Los Angeles.
>
> Coroner Creed said no inquest would be held.[20]

After Gene's body was taken away, Lloyd, Tillie, Nin, Cindy and Dave were left to themselves, with the eighty- or ninety-mile drive back to Sun Valley looming before them. Lloyd decided to drive Nin and Cindy in the Carryall, and Dave asked if he could drive Tillie in the Arnold car. Dave was devastated, wrote Tillie, and wanted something to keep his mind occupied.

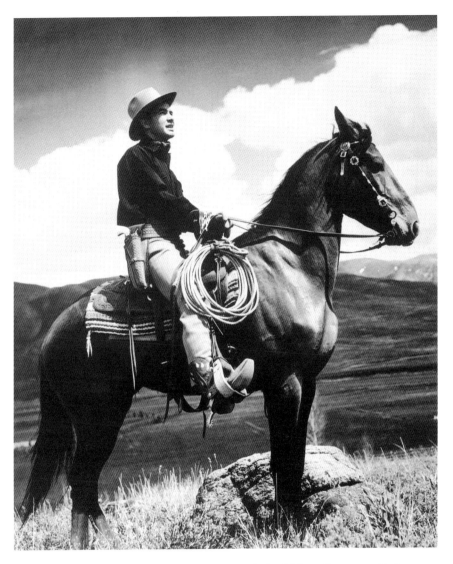

Gene Van Guilder, circa 1938. *Community Library Regional History Department, Ketchum, Idaho, F01634.*

Tillie knew that during the interminable two-hour trip, Lloyd was reliving the accident again and again and assumed that Dave was doing the same. The three hunters had carelessly disregarded the prime rule about hunting in a boat: only one person hunts; the others unload their guns. Lloyd had broken his shotgun open and removed the shells; for the rest of his life, he deeply regretted that he had not insisted that Dave do the same.

When Lloyd, Tillie and the others finally reached home Sunday evening, they found a friend waiting for them on the porch of the Sun Valley Lodge: Hem. He had happened to be in the lodge when Lloyd called. After sympathetically greeting the group, especially Nin and Cindy, Hem took Lloyd aside and talked to him. Tillie overhead the conversation. Hem said reporters would soon get word of the accident, and the phone would start ringing off the hook. He would be glad to handle the newspapers if Lloyd wished. Certainly, said Lloyd. Hem also said he had already talked with Taylor Williams, and the two of them had made arrangements for the canoe, shotguns, game and miscellaneous items to be picked up and returned to Sun Valley. Thanks to Hem, Lloyd, so shaken by Gene's death that he hardly knew where to begin, was able to concentrate on the tasks at hand. He made more phone calls, sent a telegram to New York and, after consulting with Nin, made arrangements with a funeral home.

Tillie was with Nin in her room as friends stopped with condolences and offers to help. Tillie called Clara Spiegel, a part-time Sun Valley resident who was a good friend of Nin's, and asked if she could come from Chicago to be with Nin. Clara was sick but said she would come immediately. (Clara, who had not yet met Hem, already had a connection to him because her husband, Freddie, had driven ambulances with him in World War I; she and Hem were to become good friends.)

Hem eventually came to Nin's room, and he and Tillie spoke privately. Hem said he thought Lloyd needed her more than Nin did. Tillie agreed and said goodnight to Nin. Hem was right: Tillie found Lloyd in a fragile state. Luckily, someone—probably Hem—had ordered food, and Lloyd had something to eat for the first time since early that morning. Lloyd said that Hem, like his own father, had been a "mountainous man" in a crisis and had helped Lloyd prepare telegrams, letters and press material. In addition, Gene's potlatch dinner was immediately canceled.

As promised, Hem was waiting the next morning to have breakfast with Lloyd and Tillie. By then, Hem had already fielded several press calls about Gene's death. Like Lloyd, Hem was distressed that Gene and Dave had both entered the canoe with loaded guns; still, he reminded Lloyd that he and Gene had made a great team and had never been in the habit of giving each other orders. Next, Hem brought up something that had been nagging at Lloyd, even though he hadn't mentioned it: he was afraid that Hem might leave Sun Valley on November 10, when Marty was scheduled to depart on a journalism assignment. Hem said he was not going anywhere, that he would take a stand

with Lloyd, whatever happened, clearly implying that he would fight any attempts to have Lloyd fired.

The three of them were still talking when a phone call came through from Coop, who had heard the news about Gene. Lloyd and Hem both talked to Coop for a good while, although neither recorded any details. Lloyd did mention, however, that Hem and Coop set a tentative date to meet in Sun Valley the next fall.

With a host of friends from Boise, Twin Falls and throughout the Snake River Plain present, Gene Van Guilder was laid to rest on Wednesday afternoon, November 1, a beautiful, warm day, his burial spot nestled close to the forested hills that bordered the small Ketchum Cemetery. Nin had decided on a simple graveside service and asked attendees to wear everyday western clothes in remembrance of Gene's passion for all things western. The pallbearers, including Hem and Lloyd, carried the casket from the hearse to the burial site. Next, after a minister gave a short sermon, Hem stepped forward and unrolled a manuscript typed on onionskin paper. At Nin's request, he had prepared a tribute to Gene, agreeing reluctantly to read it even though he was always nervous speaking in public.

Then, the writer who had apologetically asked Lloyd and Tillie to read and comment on the tribute, the same writer whose work the *New York Times* had called "moving and beautiful,"[21] began methodically reading the seven paragraphs he had composed about a friend he had known for less than six weeks:

*You all know Gene. Almost everyone here is better equipped to speak about him and has more right to speak of him than I have. I have written down these thoughts about him because if you trusted yourself simply to speak about Gene, there might be a time when you would be unable to go on.*

*You all know that he was a man of great talent. He had great talent for his work, for writing and for painting. But he had something more than that. He had a great talent for living and for communicating his love and enjoyment of life to others.*

*If it was a fine bright day and you were out in the hills with Gene, he made it into a better day. If it was a dark and gloomy day and you saw Gene, he made it a lot less gloomy. There weren't any bad days when Gene was around. He gave something of himself to all those who knew him or worked with him. And what he gave us all was very precious because it was compounded of the rarest elements. It was made up of true goodness,*

*of kindness, of fairness and generosity, of good humor, of tolerance and of the love of life. What he gave us he gave us for good.*

*We have that from him always. When I heard that Gene had died I would not believe it. I cannot believe it now. Yes, technically he is dead. As we all must be. But the thing he gave to those who knew him was not a thing that ever perishes and the spirit of Gene Van Guilder is not a thing that will perish either.*

*Gene loved this country. He had a true feeling and understanding of it. He saw it with the eyes of a painter, the mind of a trained writer, and the heart of a boy who had been brought up in the West, and the better he saw it and understood it, the more he loved it. He loved the hills in the spring when the snows go off and the first flowers come. He loved the warm sun of summer and the high mountain meadows, the trails through the timber and the sudden clear blue of the lakes. He loved the hills in the winter when the snow comes. Best of all he loved the fall. He told me that the other night riding home in the car from pheasant hunting, the fall with the tawny and grey, the leaves yellow on the cottonwoods, leaves floating on the trout streams and above the hills the high blue windless skies. He loved to shoot, he loved to ride and he loved to fish.*

*Now those are all finished. But the hills remain. Gene has gotten through with that thing we all have to do. His dying in his youth was a great injustice. There are no words to describe how unjust is the death of a young man. But he has finished something that we all must do.*

*And now he has come home to the hills. He has come back now to rest well in the country that he loved through all the seasons. He will be here in the winter and in the spring and in the summer, and in the fall. In all the seasons there will ever be. He has come back to the hills that he loved and now he will be a part of them forever.*[22]

Next, the casket was lowered, and several of Gene's prized possessions, including a silver-mounted saddle and bridle, as well as a pair of silver spurs Nin had given him as a birthday present, were placed on top of the casket and then covered with a saddle blanket. The pallbearers then took turns shoveling dirt into the grave. Then the pallbearers walked together over the hill toward the Sun Valley Lodge.[23]

One week later, Hem threw a going-away party for Marty at Trail Creek Cabin, where Sun Valley guests frequently met for dinner and socializing. Hem supervised the preparation of the game dishes originally planned for Gene's Armistice Day celebration, and the meal turned out perfectly.

Marty was well liked, and her new friends were sad to see her go. They were also apprehensive because her assignment from *Collier's* magazine sounded dangerous: travel to Finland and cover the threat of a Russian invasion.

Tillie had tried to persuade Marty not to go, saying that Hem would miss her and worry about her. Not offended by Tillie's unsolicited advice, Marty simply said that journalism was in her blood and she had to accept the assignment. What she didn't say was that earning much-needed money was one of her main reasons for going. Even Hem, who constantly fretted over finances, agreed that the income from *Collier's* was crucial and would allow her to write and sell short stories in the future, without taking magazine assignments.

With Marty gone and everyone still smarting from Gene's death—and Hem harping that no Indian liked to be without his squaw—his remaining month in Idaho looked to be serious and gloomy, but the novelist in residence prevented that. One day, he came to lunch in a cheerful mood, and Tillie said that his writing must be going well. Yes, he said, adding that he finally knew what was going to happen to one of his characters by the name of Pablo. Lloyd and Tillie and Taylor listened intently—this was the first time he had told them any specifics about his book. Next he asked if they would like to read the manuscript. Of course, replied Taylor, calling him "Mr. Author" and asking when they could start.

He had started on the new book on March 1; now, in mid-November, with twenty-four chapters completed, he started giving Lloyd, Tillie and Taylor a chapter or two to read each night, getting their critiques the next day at lunch. Soon, all four of them were referring to "our book's progress." One night at Glamor House, when asked what the title of the book would be, Hem went over a few possible names. Then, to propose another title, he retrieved a book of John Donne's writings from his shelf and read the following passage:

> *No man is an Iland, intire of it selfe; every man*
> *is a peece of the Continent, a part of the maine; if a*
> *Clod bee washed away by the Sea, Europe is the lesse,*
> *as well as if a Promontorie were, as well as if a Mannor*
> *of thy friends or of thine owne were; any mans death*
> *diminishes me, because I am involved in Mankinde; And*
> *therefore never send to know for whom the bell tolls;*
> *It tolls for thee.*

Speaking almost to himself, Hem added, "If a man could just write like that."[24]

By early December, Lloyd, Tillie and Taylor had read all twenty-four chapters, and Bernice Hicks, a secretary at the Sun Valley Lodge, was busy retyping the manuscript as Hem made changes. On December 8, Hem wrote to Maxwell Perkins, his good friend and editor at Scribner's, that the book was going well and he could see the finish.[25]

Four days later, Hem wrote another letter, this one to Pauline's mother, Mary Alice Downey Pfeiffer, a woman he felt closer to than his own mother. He wrote that he had very much wanted to see her and Paul (her husband) in the fall with his sons but that Pauline's coming to the L-Bar-T had changed all his plans. Next, repeating a pattern of blaming others for his troubles, he accused Pauline's sister Virginia (who went by "Ginny") of breaking up his home by telling false stories about him. Even so, his sincere affection for Pauline's parents comes through as he wrote that he missed them very much and sent his love.[26]

Mary's poignant reply shows how much she loved the man guilty of sometimes flaunting his unfaithfulness to her daughter. "Your father and I are deeply grieved," she wrote, by the trouble and misunderstandings between him and Pauline. She had come to think of him as her own son; this would be her saddest Christmas. Apparently concluding that she would never see or hear from him again, she closed, "I shall always remember you in my prayers and hope that we shall meet again in a fairer clime upon a further shore."[27] She never did see or hear from Hem again.

By this time, Toby Bruce had arrived by train to drive Hem back to Key West. After less than three months in Glamor House, Hem packed up his books, guns and gear and prepared to leave the new friends with whom he shared such mutual love and respect. In a touch that was pure Hemingway, he asked to be kept informed about two situations: whether Nin Van Guilder was able to get a job at the resort when the ski season opened and whether there was enough snow for the season to open on time. Then he and Toby said their goodbyes to a throng of well-wishers, climbed in the Buick and drove south.

On Christmas Eve, remembered Tillie, she and the other Idaho friends wired Hem with the news that Nin indeed had a job and that there was plenty of snow for the ski season. They got a reply the next morning:

*ARNOLD VAN GUILDER WILLIAMS AND EVERYBODY ELSE—SUN VALLEY IDAHO*

*MUCH LOVE AND MERRY CHRISTMAS FROM IRON MAN BRUCE AND DOCTOR HEMINGSTEIN STOP THERE ISN'T ENOUGH DOUGH IN CUBA TO SEND MESSAGES TO EVERYONE AM FOND OF THERE. HEMINGSTEIN[28]*

# "LIKE TWO SCHOOLBOYS"

On Saturday afternoon, September 28, 1940, one year, one week and one day after Hemingway's appearance, thirty-nine-year-old Gary Cooper; his wife, Veronica, always called "Rocky," twenty-seven; and their three-year-old daughter, Maria, arrived at the Sun Valley Lodge. After they checked into their suite, Coop went down to the camera shop to see Lloyd and Tillie and to give Lloyd some hand-loaded, big-game ammunition. The three of them visited for a while, but the unassuming Coop said nothing about the movie he had recently completed shooting, directed by Frank Capra and co-starring Barbara Stanwyck. As Tillie put it, the beautiful thing about Coop was that he never seemed to be aware of his stardom and was as down to earth as the characters he portrayed on the screen. Hearing that meant a lot to Hem, she added, because he could not tolerate a phony.

After hearing about an elk hunt Lloyd had planned, Coop asked, "Now where you hidin' this fella Hemingway? I hear he's settled here again. I feel like I know him."

Hem and Marty had arrived three weeks earlier, and Toby and Hem's three sons a week before that, Tillie explained. Then she called suite 206 and handed the phone to Coop. He and Hem talked briefly and arranged to meet later. Even from hearing just one side of the conversation, Tillie believed Hem and Coop would get along well.

Handing the phone back to Tillie, Coop said, "Thanks, Tillie gal, podnuh, see ya later ah'll bet." Neither Lloyd nor Tillie was present later that day when Taylor Williams, who had spent several weeks that spring fishing with

The Sun Valley Lodge, where Hemingway wrote part of *For Whom the Bell Tolls*. *Photo by the author, 2016.*

Hem in Cuba, introduced Hem and Coop at the Sun Valley Gun Club. Taylor offered a sketchy but tantalizing report: they approached each other like two schoolboys standing on opposite sides of a line scratched in the dirt, sizing each other up; then they quickly "got 'er done."

No one was surprised that Hem and Marty met Coop and Rocky the next morning at the gun club, starting with trap shooting and then moving to skeet. Marty did not take naturally to guns but had learned how to shoot and hunt to please Hem. It was a different story with Rocky, who was a champion skeet shooter and, in Lloyd's words, "could shoot the pants off all of us."[29]

Hem and Coop both had a passion for shooting and hunting. Both had decorated their homes with the heads and antlers of big game they had killed. Following the tradition of Teddy Roosevelt, both had gone on months-long safaris in Africa, stalking and killing lions, rhinos, Cape buffalo, antelopes, hyenas and the like. Both loved the American West, particularly the Montana-Idaho-Wyoming region. Coop was a Montana native and maintained his connections there; as noted, Hem loved the wilderness area along the Montana/Wyoming border—near the northeast corner of

Yellowstone Park—and had visited the area annually throughout the 1930s. Now the two found themselves in the West they cherished—only a few hours away from either Montana or Wyoming—with the Snake River Plain offering extraordinary bird hunting and the Sun Valley resort and Trail Creek Cabin offering first-rate accommodations and the perfect atmosphere for socializing. It made perfect sense that the first thing Hem and Coop did together was shoot and that one of the first things Hem discussed in his first letter mentioning Coop was that he was a little better shot than Coop with a shotgun but that Coop was a much better shot with a rifle.[30]

No one could doubt that the writer and actor would make great hunting pals whenever they were both in Sun Valley, but it was hardly a foregone conclusion that they would become close friends. It seemed quite possible that they were simply too different to develop such a bond. First of all, they weren't likely to find common ground politically. Like his father, Coop was a conservative Republican who had voted for Coolidge in 1924 and for Hoover in 1928 and 1932. More recently, he had campaigned for Republican Wendell Willkie (running against President Franklin Delano Roosevelt) just months before meeting Hem. By contrast, Hem was a liberal who had voted for Socialist

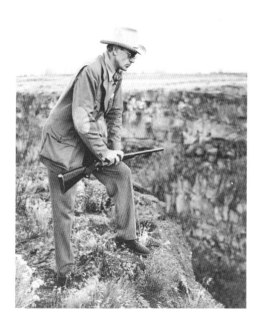
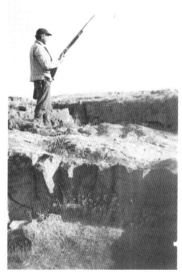

Gary Cooper (*left*) and Ernest Hemingway (*right*) hunting along the Malad Gorge, northeast of Hagerman. *Photographer unknown, Papers of Ernest Hemingway, Photograph Collection, John F. Kennedy Presidential Library and Museum, Boston.*

candidate Eugene V. Debs as a young man and during the Spanish civil war had been an ardent supporter of the Loyalists, who sought Communist Russia's help in their struggle with the Nationalists (who allied themselves with the fascist regimes in Italy and Germany).[31]

Another case in point: Tillie noted that if there was one thing Hem was excessive with, it was reading, not drinking. Virtually every time she and Lloyd went to Glamor House, they found Hem reading. Indeed, Tom Dardis went so far as to call Hemingway "perhaps the best-read American novelist of the century."[32] Coop, on the other hand, had little interest in reading for long periods of time, even reportedly claiming in one interview (no doubt with a touch of that Cooper wit) that he hadn't read six books in his entire life.[33]

Again, Hemingway's reputation as a loud, larger-than-life, fun-loving, hard-drinking, brash individual known for challenging friends or even acquaintances to boxing matches hardly fit with Gary Cooper's image as a moderate-drinking (but heavy-smoking), courteous, non-confrontational, taciturn man.

Another obvious difference was their attitude toward friendship itself. As Jeffery Meyers has noted, Hemingway had a genius for friendship and made an amazing number of friends in Paris between 1922 and 1925. The list included Ezra Pound, Gertrude Stein, Sylvia Beach, James Joyce, Lincoln Steffans, Wyndham Lewis, Ford Madox Ford, John Dos Passos, Evan Shipman, Archibald MacLeish, F. Scott Fitzgerald and Sara and Gerald Murphy, to name a few. As his onetime good friend Don Stewart pointed out, however, Hemingway was also a prolific breaker of friendships.[34]

The opposite was true of Coop: he liked solitude and tended not to confide in others but stayed loyal to the few close friends he had. Fellow actors Walter Brennan and Joel McCrea were two of them. Even though Coop had haggled with the producers about his role in *The Westerner*, he was pleased when Brennan won the Oscar for best supporting actor. "Don't know what they needed me for in *The Westerner*," he said. "It didn't require any effort on my part." Director Billy Wilder said Cooper and Brennan knew each other so well that they played their roles instinctively: "Each knew what the other was going to do."[35]

Adding to this study in contrasts, Hemingway was quite generous with his money. He repaid debts even when he was poor, supported his mother and his younger siblings after his father's death and gave substantial amounts of money to Dos Passos and many others, while Cooper, according to one biographer, "was always careful about money and not overgenerous when it came to helping others."[36]

All of that notwithstanding, Hem and Coop forged a close and unique comradeship that endured from their first conversation and first meeting in 1939 and '40 to their deaths seven weeks apart in 1961. Gregory Hemingway and Lloyd Arnold both offered valuable clues as to why that friendship lasted. Gregory, who described Coop as "gentle, courteous, and innately noble," added that while the two men "had little in common intellectually, a kindness and gentleness seemed to exist between them. And they really did enjoy each other—you could tell by the resonance of their voices and the way their eyes smiled."[37]

Lloyd pinpointed an event on September 29 that moved their relationship far beyond the pleasures of hunting or socializing. After they had been shooting with Rocky and Marty at the gun club, Lloyd drove Hem and Coop to a newsstand where Hem always bought newspapers. Then Hem asked if Lloyd would drive them "over the hill." Lloyd was puzzled for a second but then understood Hem's meaning and made the short drive to the cemetery. As they got out of the car and walked toward Gene Van Guilder's grave, Lloyd explained that Nin had married Winston McCrea, assistant manager of one of the Sun Valley hotels, in June and that the work of a local stonemason now marked the burial site. In the stillness of the small cemetery, they studied the "headstone" that was perfect for Gene, a granite boulder holding a bronze plate inscribed with Gene's name and dates (1905–1939) and the concluding sentence of Hem's eulogy: "He has come back to the hills he loved and now he will be a part of them forever."

"A hell of a guy," said Hem. In his typical way, Coop almost whispered his agreement in a syllable or two. Then neither of them said anything more. All three men were silent on the way back to the lodge, but Lloyd felt certain that Hem and Coop "got the measure they both looked for."[38]

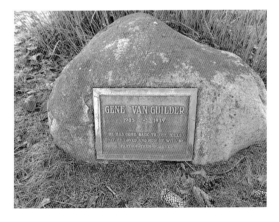

Gene Van Guilder's headstone; the quote is from Hemingway's eulogy. *Photo by the author, 2016.*

Hem confirmed Lloyd's hunch two weeks later when he wrote to Maxwell Perkins that Coop was "a fine man; as honest and straight and friendly and unspoiled as he looks,"[39] a high recommendation from a man who frequently gave signals, albeit mixed with contrary signs of overblown machismo, that he hoped to be perceived similarly.

One week after Coop arrived, the advance copies of *For Whom the Bell Tolls* came from New York, and a celebration was held at Glamor House. Everyone was pleased and not surprised when they saw the dedication page: "This book is for MARTHA GELLHORN." Hem gave away signed copies to Taylor, Lloyd and Tillie, Bernice Hicks and others, including Coop and Rocky, whose copy included this inscription: "To the Coopers, to make something to supplement the Idaho Statesman as reading matter. With good luck always, Ernest Hemingway. On the day we got books. October 5, 1940."[40]

Like much of Hem's fiction, *Bell* included elements that were conspicuously autobiographical. When Robert Jordan, the fluent Spanish-speaking hero of the story, remembers his grandfather, who fought in the American Civil War, and his father, who committed suicide, for example, it might as well be Hem writing a nonfiction memoir. But the description of Jordan as a "tall and thin" Montanan, "with sun-streaked fair hair, and a wind- and sun-burned face," sounds remarkably like Cooper, not Hemingway. One biographer of the actor even claims that the writer had Cooper in mind as he wrote *Bell*: "[In 1940] Hemingway invited Cooper to read his new novel, which he had in galley proof. Cooper read *For Whom the Bell Tolls*, admired it immensely, and told Hemingway that if a movie should be made of it, he'd certainly like to have a go at the Robert Jordan role. 'That's good,' Hemingway grinned, 'because it was written for you.'"[41]

Many years later, Patrick Hemingway confirmed in an interview that his father did have Gary Cooper in mind as he wrote *For Whom the Bell Tolls*.[42] This was not surprising because Hem had admired Coop's 1932 performance in *A Farewell to Arms*, even though he was contemptuous of the movie in general.

Thus, by the time a movie version of *For Whom the Bell Tolls* was in the works—which happened virtually as soon as the book was published—a fictional character that was part Hemingway and part Cooper and a nonfictional union of trust and affection between the two men had both been born. "In those early days, things seemed simple and unspoiled," Coop and Rocky's daughter Maria wrote almost sixty years later. "As

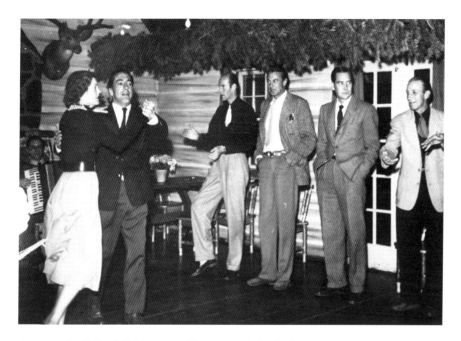

A party at Trail Creek Cabin, 1947. *From left to right*: Rocky Cooper, Fred Iselin, Mac McCrea, Gary Cooper, Morgan Heap and Lloyd Arnold. *Community Library Regional History Department, Ketchum, Idaho, F01699.*

Ernest said, 'I've never had it so good.'" Maria added that Ernest always made things fun but that he and her father never made drinking part of the fun when they were hunting or handling guns. "When Ernest Hemingway became part of the life of the valley," concluded Maria, "the two men met and formed a bond, perhaps unlikely, that existed whether in Idaho or Cuba or Paris or New York for as long as they lived."[43]

With Lloyd Arnold and the renowned war photographer Robert Capa, whom Hem had met and befriended in Spain, both shooting photos, the "simple and unspoiled" days enjoyed by Hem and Coop were well chronicled: the two (in the first photo taken of them) standing on a country road next to Hem's Buick, holding their shotguns and staring out at the Snake River Plain; Hem, Rocky (the California State Women's Skeet Champion, who didn't use her skill to kill animals) and Coop checking the winds as they watch the trajectory of skeet pigeons; Hem, Marty, Jack, Patrick and Gregory (and a hunting dog) after a successful pheasant hunt; and dinner and wine at the Trail Creek Cabin, with Coop, Marty, Dorothy Parker, Mac McCrea, Lloyd, Tillie, Taylor, Nin, Allen Campbell, Hem and Rocky thoroughly enjoying themselves.

A view of Trail Creek Cabin, near the bottom edge of the evergreens, from the Hemingway Memorial. *Photo by the author, 2016.*

There seemed to be no end to the good news. By the time *For Whom the Bell Tolls* was officially released on October 21, Scribner's and the Book-of-the-Month Club were both heavily promoting it. The *New York Times* said the book was "a tremendous piece of work…the most moving document to date on the Spanish Civil War," Hemingway's "finest novel." *Saturday Review of Literature* called the book "one of the finest and richest novels of the last decade."[44]

Hem's hope that he had a bestseller on his hands was hardly wishful thinking: before the end of October, the Book-of-the-Month Club upped its initial order to an incredible 200,000 copies and Scribner's had already gone to a third printing, for a total of 360,000 copies. Paramount Pictures soon offered $100,000 for the film rights; Hem accepted.

The forty-one-year-old Hemingway and the thirty-nine-year-old Cooper now shared something else: tremendous critical and popular acclaim in their chosen professions. Their hard work and spare style had propelled them both into prominence at virtually the same time, with Hem's novels *The Sun Also Rises* (1926) and *A Farewell to Arms* (1929) and Coop's films *Wings* (1927)

and *The Virginian* (1929). Now many critics considered Hem the best fiction writer in America, if not the world, and as he wrote to Hadley, his latest novel was "selling like frozen daiquiris in hell." For his part, Coop had been nominated for the best actor Oscar for *Mr. Deeds Goes to Town* (1936) and had been earning well over $250,000 a year since the mid-1930s. In 1939, the same year Hem began writing *Bell*, Coop's salary was an incredible $482,826, the highest in the United States.

Little wonder that the writer and the actor, both naturally shy but now thrust into the blinding glare and tumult of celebrity and success, found an unmatched solace by walking along country roads or up and down hills thick with sagebrush, shotguns slung over shoulders, understanding each other and not saying a word.

One incident from that autumn reveals just how much Hem had come to trust and respect Coop. On a pleasant afternoon in October, Coop and Rocky and Marty were waiting by the car, ready to leave on a pheasant hunting excursion, when Hem went out of his way to loudly rebuke a Sun Valley employee who had interrupted his writing earlier. The young man was contrite, but Hem lit into him with relish. Marty and Rocky were both disgusted with Hem's antics, and both refused to leave, only getting in the back seat of the car after Coop gently persuaded them to. Then Hem himself came over to the car, with Coop sitting in the driver's seat, and got in the front passenger side. Coop and Hem looked at each other, but neither spoke. Coop, who had not started the car and made no effort to do so, sat still. Finally, Hem got out of the car, walked over to the young man and apologized (later seeing to it that the employee was not disciplined). Getting back in the car, Hem said, "Now are you satisfied, you long-legged son of a bitch?" Coop didn't answer—but probably smiled—as he drove out of the lodge parking lot.[45]

As Sean Hemingway, a grandson of Hem's born in 1967, said, "Gary Cooper had an effect on my grandfather like no one else he ever knew."[46] But Hem himself summed it up best: "If you made up a character like Coop, nobody would believe it. He's just too good to be true."[47]

Coop, Rocky and Maria returned to California the last week of October. Not long after that, Coop flew to Dallas for the premiere of *The Westerner*, where, dressed like Cole Harden, he led a parade on horseback. Even so, Coop was mainly preoccupied with his upcoming film about the famed hero of World War I Alvin York. Born and raised in the backwoods of Tennessee and a hell-raiser as a youth, York experienced a Christian conversion and declared himself a conscientious objector when he was

The Big Wood River (*top*) and surrounding area (*bottom*). *Photo by the author, 2016.*

required to register for the draft in 1917. His application was denied, and he was drafted the same year, one month short of his thirtieth birthday. After consulting with superior officers, who were also devout Christians, York decided it was his solemn duty to fight and that a Divine Hand would protect him. At the Battle of the Argonne Forest in France in October 1918, in what seemed to be a hopeless suicide mission, York led seven others toward a nest of German machine guns, somehow killing 28 German machine gunners, taking 132 prisoners and disrupting an entire battalion about to counterattack the Americans.

In 1919, when movie producer Jesse Lasky learned of York's incredible valor, he tried—along with a host of others—to purchase the film rights to York's story. "Uncle Sam's uniform, [it] ain't for sale," replied the modest York. Over the years, the resolute Congressional Medal of Honor winner turned Lasky down again and again, but in 1939, with Hitler on a rampage, Lasky, who had helped Coop make his name in the 1920s, gave it another try, this time with a sleight-of-hand the straight-laced Tennessean never would have approved. Lasky, who had Coop in mind for the starring role, sent Coop a telegram supposedly from Alvin York saying Coop was the only actor to play him. Lasky next sent another wire, this one to York supposedly from Coop saying he'd love to do the film.

Coop learned of this subterfuge soon enough; whether York ever found out is not clear, but the notion of Coop playing him was not a hard sell. It was a different story with Coop. First, Paramount Pictures would have to loan him to Warner Bros., which had agreed to produce the film. Second, Coop would have to feel comfortable with the part, and he wasn't, summing up his reaction this way: "In screen biographies, dealing with remote historical characters, some romantic leeway is permissible. But York happened to be very much alive, his exploits were real, and I felt that I couldn't do justice to him. York himself came to tell me I was his own choice for the role, but I still felt I couldn't handle it....He was too big for me, he covered too much territory."[48]

In saying all of this, however, Coop was simply revealing that he really was right for the role because he and the unassuming York were so much alike. Prompting from good friend and director Howard Hawks, who reminded Coop how Lasky had helped him fifteen years earlier, softened Coop's attitude. Then he made a trip to the Tennessee hills to visit York. Just as he had with Hem, Coop broke the ice with York by talking about their mutual interests in guns and hunting. Coop, who would eventually call York his favorite role, reported after the meeting: "Sergeant York and I had quite

a few things in common…we were both raised in the mountains—Tennessee for him, Montana for me—and learned to ride and shoot as a natural part of growing up. Physically, I looked pretty much as he did when he became the outstanding hero of the first World War."[49]

Finally, studio arrangements were made, and both York and Coop signed deals, with a good portion of York's income going directly to build a Bible school in the valley where he farmed. By the time Coop made his visit to Dallas in November, plans were all set for him to begin shooting *Sergeant York* early in February 1941.

Coop and Rocky had no doubt seen the November 5 Associated Press story announcing "Mrs. Ernest Hemingway Wins Divorce Suit." Two and a half weeks later, another story on Hemingway made an even bigger splash, this one surprising none of Hem's Idaho friends or the Coopers: "Ernest Hemingway Takes Third Wife." Hem, forty-one, and Marty, thirty-two, had been married in Cheyenne, Wyoming, on November 21 by a justice of the peace in the dining room of the Union Pacific Railroad depot. After the brief ceremony, the happy couple feasted on roast moose.

Hem and Marty drove to Kansas City and then on to New York, where they spent three weeks at the Lombardy Hotel entertaining visitors like Hem's son Jack, the boxing trainer George Brown, Robert Capa and H.G. Wells, an acquaintance of Marty's who was "most anxious" to meet Hemingway. Marty, who had covered the war in Spain with Hem in the late 1930s and the Russian invasion of Finland in early 1940, now finalized her plans with *Collier's* to cover the war between Japan and China, especially activity along the Burma Road, a supply line that linked India, Burma and southwest China. Hem, who preferred to spend a long honeymoon with Marty in Cuba, reluctantly decided to accompany her and made arrangements with a new liberal New York newspaper called *PM* to act as a war correspondent himself. A few weeks later, Harry Dexter White, the Treasury Department's director of monetary research (who had heard of Hemingway's assignment with *PM*), contacted Hemingway and asked him to collect and report information on the Burma Road, as well as on the relationship between the Kuomintang, which had been the dominant political party in China since the 1920s and was now led by Chiang Kai-shek, and the Chinese Communists, led by Mao Tse-tung and Chou En-lai. Hemingway agreed.[50]

Hem and Marty were on their way to Cuba when they got word on December 21 that forty-four-year-old F. Scott Fitzgerald had died in Los Angeles of a heart attack. Hem had met Scott in Paris in 1925, when Scott was at the height of his success. Over the next fifteen years, Scott's career

had declined just as dramatically as Hem's had flourished. Both men had serious problems with alcohol, but Hem could hold his liquor, while Scott (whom Hem considered a "rummy") frequently made a fool of himself or passed out (or both) when drunk. The close friendship between the two men waxed and waned, with Hem sometimes gentle and sometimes cruel. Still, ten years after they met, Scott had written Max Perkins, "I always think of my friendship with [Hemingway] as being one of the high spots of life."[51]

Three weeks after Scott's death, on January 13, 1941, fifty-eight-year-old James Joyce died in Zurich, Switzerland, of complications from surgery for a perforated ulcer. Hem had also met him in Paris, in 1922; enjoyed his friendship, especially when they were drinking together; had learned much from "the Joycean technique of compressing insights into a single epiphanic moment"; and called Joyce "the greatest writer in the world."[52]

A week or two after Joyce's death, Hem and Marty left La Finca Vigía, the house about ten miles from Havana that Hem had purchased, and made their way back to New York. They were preparing to leave for China when Hem got a call from another old Paris friend, Solita Solano. She had escaped Paris when it fell to Germany in the late spring of 1940 and was now living in lower Manhattan. She and Hem likely reminisced about the night years earlier when they had managed to get an inebriated and helpless Joyce back to his flat. Then the conversation turned serious as Solita told Hem how Margaret Anderson, former editor of the *Little Review* and publisher of some of Hem's early short stories, had stayed in Paris to care for Georgette Leblanc Maeterlinck, a friend with cancer. Georgette had died, and Margaret was now stranded and poor but hoping to arrange for passage to New York.

Under the weather and hurriedly packing to fly west, Hem wasn't able to see Solita but responded with a short note sending his love and wishing Margaret good luck in getting to the United States. He told Solita not to worry "because as long as any of us have any money we all have money." Enclosed with the note was a check for Margaret for $400, a considerable sum for the time.[53] Sending money to a friend in trouble was vintage Hemingway, something he often did throughout the years, always without fanfare.

Late that same day, January 27, Hem and Marty flew out of the Newark Airport for Los Angeles, the eighteen-hour flight (with three refueling stops) giving Hem plenty of time to contemplate the deaths and hardships of his Paris comrades and how those days with Hadley and Bumby and a wealth of friends were lost forever. His somber mood and his and Marty's exhaustion were forgotten, however, when they were greeted with hugs and handshakes from Coop and Rocky and smiles from Maria at the

Grand Central Airport in Glendale, followed by good conversation and the warmth and comfort of the Cooper home, where they would stay for the next two nights. Coop and Rocky lived in a white Gregorian mansion a few miles southwest of Beverly Hills in Brentwood, and their three-and-a-half-acre spread—with a vegetable garden, an orange grove, a tennis court and a swimming pool—gave Coop and Hem a perfect opportunity to enjoy their quiet fellowship, especially among animal friends that included ducks and chickens and several dogs.

The Hemingways and the Coopers saw the sights of Los Angeles, and Hem and Coop consulted with Paramount Pictures about the movie version of *For Whom the Bell Tolls*. Whether that meeting resulted in Hem's meeting Ingrid Bergman a few days later is uncertain, but the January 6 issue of *LIFE* magazine had already announced that the author of the bestselling novel wanted Gary Cooper and Ingrid Bergman to play the lead roles of Robert Jordan and Maria, the young girl raped by Nationalist Fascists who falls in love with Jordan. Ingrid saw the article, and thrilled with the prospect of playing Maria, she immediately called her producer and friend David O. Selznick. He said he had seen the article and agreed she was right for the part, but when he reminded her that Paramount had the rights, she reminded him that he had influence with Paramount. Selznick promised he would call Paramount and would do everything he could to help her get the part.

One way or another, probably while the Hemingways were still staying at the Cooper home, Selznick got in touch with Hem, who said he'd be very interested in meeting Ingrid Bergman. The upshot was that Selznick called Ingrid, in Sun Valley, of all places, where she and her husband, Petter Lindstrom, just happened to be enjoying a skiing vacation. Selznick told her that Ernest Hemingway and his wife were now in San Francisco (754 miles away) and wanted to know if it was possible for her to meet them. "Possible?" she wrote. "I am already on my way. So Petter and I race off by car and train and we meet Ernest Hemingway and his wife, Martha Gellhorn, at a restaurant in San Francisco." After taking a good long look at Ingrid, Hem said he shouldn't have wondered if she were really right for the role. Then he asked Ingrid about her ears; she said she could hear just fine but then realized he meant how they looked because Maria's hair was quite short. Lifting her hair to reveal her ears, Ingrid asked how he could want a Nordie to play a Spanish girl. He said he'd seen Spanish girls just like her. "They're tall and blond, many of them. You'll get the part, don't worry." But she was worried because she "knew that Paramount had the final say in the

matter, not the author, and that already they were considering other girls. So Ernest Hemingway left for China and that was that."[54]

As Ingrid would eventually learn, however, that was not that at all. True, Hem had no official say in who would get the part, but the copy of *For Whom the Bell Tolls* he gave her that Thursday in January at Jack's Restaurant on Sacramento Street included an inscription—"For Ingrid Bergman, who is the Maria of this story"—that would prove prophetic.[55]

As Hem and Marty set sail on *Matsonia* for Honolulu on Friday, January 31, 1941, the world looked different than it had when they left New York five days earlier. Two of the great friends of Hem's youth, Scott and Joyce, may have been lost forever, along with his youth itself, but his camaraderie with Coop and Ingrid, destined to become two of the great friends of his middle age, had restored his confidence that life was good.

Two days later, Coop and Walter Brennan were guests on the Veterans of Foreign Wars tenth anniversary *Hello America* radio program, re-creating the parts they would play in *Sergeant York*. Shooting began a week later (a few days after the Hemingways were greeted in Honolulu by a throng of photographers snapping pictures and reporters yelling questions), with most of it taking place at the Warner Bros. studio in Burbank or at an eighty-acre barley ranch in the Simi Hills, about forty miles northwest of Los Angeles.

*Sergeant York* included more speaking parts than any movie in history except *Anthony Adverse* (also produced by Warner Bros.). More than 120 sets were used, including a 135- by 250-foot soundstage used to re-create York's home country in Tennessee's Valley of the Three Forks of the Wolf River. The farm in Simi Valley was chosen for the battle scenes, which proved to be realistic and powerful because it resembled Argonne, and between two hundred and five hundred extras were used each day as soldiers.[56]

Coop felt quite uncomfortable doing romantic scenes with co-star Joan Leslie, who played York's fiancée (she had just turned sixteen and was twenty-four years his junior), but that didn't show onscreen. (Alvin York had requested an actress who didn't smoke or drink for the role.) Coop's interactions with the other youngsters on the set, however, revealed his easygoing, personable style. Fifteen-year-old Dickie Moore played York's younger brother, and he and Coop got along fine, with Coop introducing him to falconry and advising him to buy a Winchester 62-A pump as his first rifle. June Lockhart, also fifteen and best known among baby boomers for her television roles in *Lassie* and *Lost in Space*, played York's younger sister. She said Gary related to her despite her youth and enjoyed watching her fly

a kite when neither of them was on the set. "Cooper was very supportive of me," she said. "It gave one a feeling of affectionate nurturing."[57]

Just two or three weeks into filming, on February 27, at the Thirteenth Academy Awards, Walter Brennan won his third Oscar for best supporting actor, this one for his portrayal of Judge Roy Bean in *The Westerner* (he had won in 1936 for *Come and Get It* and in 1938 for *Kentucky*). Jimmy Stewart won the best actor award for *The Philadelphia Story*, John Ford best director for *The Grapes of Wrath* and *Rebecca* outstanding production. But when the March 3 issue of *Time* magazine appeared on the newsstands, it said nothing about the Oscars, instead featuring a portrait of Coop on the cover, with the caption:

*Gary Cooper—John Doe*

Beneath the caption were the words, "He made the cover," delightfully ironic because, as the article itself, aptly titled "Coop," pointed out, the fictional John Doe makes such a reputation for himself that he appears on the cover of *Time*. (The difference is that Coop is smiling in the make-believe cover but serious in the real one.) The first third of the long article reviewed director Frank Capra and screenwriter Robert Riskin's *Meet John Doe*, a picture that "has many excellent, many not so excellent details, and will doubtless accent for millions the virtues of neighborly compassion." Although well-intended in proclaiming the "simplest and oldest of themes: Love Thy Neighbor," the film fell short of "Bachian power" and settled instead for "Lisztian super-schmalz."

Two photos accompanied the article—one of a smiling Rocky holding one of the Coopers' dogs and the other a still from the movie, with the ubiquitous Brennan standing to one side of Coop while Barbara Stanwyck and several other cast members stand to the other. And while the conclusion of the review labeled *Doe* "super-schmalz," the caption to the photo read as follows:

*Tramp, Doe, Girl, Publisher, Soda Jerker*
*It really works and inspires.*

In the scene, a tramp (Brennan), Doe (Cooper), the girl (Stanwyck) and the publisher (Edward Arnold) have just heard a "soda jerker" by the name of Bert Hansen (Regis Toomey) explain how the story of John Doe threatening to kill himself if people didn't start treating one another better

(pure fantasy created by Stanwyck's Ann Mitchell, who convinced Doe to go along with the charade) inspired him and others to get to know their outcast neighbors and treat them with love and respect. (Bert the soda jerker is also the one who convinces Doe—serious this time—not to kill himself at the end of the film.)

As the article contends, the scene contains "some of the best character acting on film," essentially acknowledging that Capra's over-the-top sentimentality is just what is needed by the John and Mary Does of a nation increasingly threatened by the prospect of sending millions of its young men to war. The film and especially the scene in question really do work and inspire. But the *TIME* reviewer failed to mention the key element of the scene: Coop's, and Doe's, silence. Bert the soda jerker goes on and on, even admitting at one point that he's talking too much, reporting one detail after another on the reconciliation of various folks and introducing some of them, in a monologue that drones on for more than five minutes. Coop/Doe listens carefully but never says a word, his expressions alone revealing his gauntlet of emotions. It was Coop at his best, playing a man who knew when not to talk, the kind of man Hem would have appreciated.

Next came a biography of Coop himself, the 6-foot 2¾-inch, 175-pound, forty-year-old cowboy who would resemble Abraham Lincoln if he grew a beard. As the "most popular man in the nation," Coop was the perfect actor to play John Doe. Yes, he was at home in the West, where he learned to ride horses and punch cattle, but was the son of a Montana Supreme Court justice and never a cowboy by trade. He attended Helena public schools until he was nine and then spent four years in his father's native England, graduated from Bozeman High School and attended Iowa's Grinnell College for two years. After trying his hand at commercial art, he signed on as a cowboy extra in silent movies. Then he got a break when Sam Goldwyn gave him the second male lead in *The Winning of Barbara Worth* (1926).

In a few short years, Coop's pay went from $75 a week to $1,750 a week, with his persona appealing not only to the box office but also to "Hollywood's ladies." He was first involved with Clara Bow, "a violently impulsive young woman," but she was eventually replaced by another hot-blooded actress, Lupe Velez. Almost three years later, Coop took off for Europe, where Countess Dorothy di Frasso, an international socialite, tutored him in the ways of high Hollywood society, showed him off in Rome and took him on an African safari. Upon Coop's return to the pictures, he doubled his previous salary and did not disappoint, with popular yarns like *A Farewell to Arms, Beau Geste* and *Mr. Deeds Goes to Town*. Coop's "indestructible naturalness," which

"almost every American likes to identify with himself," was the key to his incredible appeal to all kinds of Americans.

*TIME* concluded with Coop the family man, telling how the cowboy had met Veronica Balfe, aka the actress Sandra Shaw, at a party in 1933 and married her and how the couple now entertained the likes of Joel McCrea and Fred MacMurray and their wives, enjoying tennis and backgammon. Coop's love of guns was noted, as was Rocky's skeet shooting skill, but there was no mention of the famed writer who had recently become Coop's favorite hunting companion. The final paragraph introduced three-year-old Maria Veronica Balfe Cooper and told how when Coop was shooting *Beau Geste* in the desert country of Arizona's Buttercup Valley, Rocky and Maria were staying in Phoenix. When Coop got word that Maria was sick, he wanted to call Rocky, but the nearest phone was nineteen miles east. Coop knew he could hitchhike if he could just make it to the state highway, but the wooden road (constructed specifically for the movie) leading there was blocked by a blinding sandstorm. "The cowboy reached it on a camel."[58]

The filming of *Sergeant York* wrapped up on May 1. Two months later, the picture premiered at New York's Astor Theater, and Coop and Rocky greeted Eleanor Roosevelt, Wendell Willkie, Henry Luce, General John Pershing and Alvin York himself, who was very appreciative of Coop's performance. Now preaching a prowar doctrine, York later said, "Millions of Americans like myself must be facing the same questions, the same uncertainties which we faced and I believe resolved for the right some twenty-four years ago."[59]

In Idaho, Lloyd and Tillie grew increasingly worried about the war, especially Germany's invasion of Russia and the number of ships being sunk by German U-boats in the Atlantic. Their mood lightened considerably in September when first Toby arrived in a new Lincoln Continental convertible with Patrick and Gregory, then Jack in his own car, a '37 Pontiac, and finally Hem, who came by train from Chicago and was picked up by Toby in Shoshone. Marty also came by train, joining them in October. "It was a happy reunion," wrote Tillie, "and for weeks we were regaled with tales of the Burma Road/China adventure."[60]

After leaving San Francisco on January 31 and spending two weeks in Hawaii, Hem and Marty had daisy-chained their way across the Pacific before reaching Hong Kong on February 22. Three months later, they returned to San Francisco separately, with Hem arriving on May 19 and Marty on May 27. They saw war-ravaged China, invaded by Japan in 1937, up close and personal—masses on the verge of starvation, children doomed to a life of slave labor, widespread civilian deaths from the fighting

and sufferers of malaria, tuberculosis or leprosy wandering everywhere amid squalor and filth. There were interminable, nerve-racking trips (one lasting twenty-five hours and another forty-three) back and forth to the front, the two of them packed into freight planes with no cabin pressure or claustrophobic boats or trains. Hem took it all in stride, even repeatedly finding drinking buddies, but the normally unflappable Marty found herself repulsed, constantly on edge, frequently nauseated and plagued by a persistent rash on her hands.[61] Tillie remembered that Marty didn't seem to have her normal energy—little wonder.

Coop and Rocky and Maria soon arrived, and it was clear that Hem and Coop hadn't missed a beat—they were off almost immediately to Silver Creek. One of Lloyd's most memorable photos shows Hem, Coop and Taylor (always called "Beartracks" by Coop) sitting on a log after a successful duck hunt in October 1941, two hunting dogs waiting patiently nearby, the peaceful expressions of all three unassuming men revealing the depth of their fellowship.

Besides seeing each other in January, Hem and Coop had also had contact during the summer, when Hem wrote Coop a letter asking about the status of the film version of *For Whom the Bell Tolls*. Hem wrote to a friend that he had signed with Paramount so Coop could play Robert Jordan and also have a voice in choosing the director, but it seemed that Sam Goldwyn was making trouble about Coop being in the picture at all. Hem also said Paramount had been spreading false rumors that he had discovered the perfect Cuban girl to play Maria. Welcome to Hollywood.[62]

Other arrivals in Sun Valley included Howard Hawks, the director of *Sergeant York*, and his young fiancée, the beautiful and personable Nancy "Slim" Gross, whom Hem had known in Key West, as well as Robert Taylor and his wife, Barbara Stanwyck, Coop's co-star in *Meet John Doe*.

"I had never known anyone so intelligent," Slim later wrote of Hem. "His mind was like a light…illuminating corners in your own head that you didn't even know were there. He had a tremendous influence on my thinking, my literary taste, [and] my recognition of and distaste for pomposity."[63]

In a letter to Max Perkins, Hem called Coop "wonderful" but said he was exhausted by making too many films and needed a rest. There was still a chance that he would appear in *For Whom the Bell Tolls*. In October, Coop, Hem and Hawks took time out from hunting to discuss the film, with high hopes that Coop would indeed play Jordan and that Hawks would direct.[64]

Others joined in: talent agent and film producer Leland Hayward and his wife, actress Margaret Sullavan; the novelist and poet Christopher

The Upper Pahsimeroi Valley, where Hemingway made his great shot. *Photo by G. Thomas.*

LaFarge, who had hunted in Idaho with Hem two years earlier; Sun Valley regulars Clara and Fred Spiegel; local rancher Bud Purdy; tennis pro Roland Bloomstrand; *Cincinnati Inquirer* outdoor writer Dave Roberts, a friend of both Hem and Taylor; and Robert Capa, back for the second October in a row.

Hunting was, naturally, the main activity. On a trip to the Pahsimeroi Valley with his sons, Lloyd, Taylor and a few others, Hem got off the shot of his life when he halted suddenly from a dead run, aimed and fired in one motion and brought down a buck antelope from 275 yards away.[65] For pheasant hunts, "General Hemingway" sometimes organized the forces that often included more than twenty armed participants. At other times, smaller groups went out together. Hem, Coop, Lloyd, Howard Hawks and John Boettiger hunted together several times on Silver Creek.

At least three times during the season, Hem added what Tillie called "a humanitarian action" to a group pheasant hunt. Everyone drove to a farm near Dietrich owned by a family by the name of Frieze. Still suffering the effects of the Depression, the family needed a good supply of hay to get their stock through the winter, but the hay crop was seriously threatened by hordes of jackrabbits that thrived in the sagebrush country of the Snake River Plain. Farmers throughout much of southern Idaho faced similar problems. Hem took control, giving strict instructions about when and in what direction various hunters could fire their weapons. "John Frieze and his two sons," wrote Jack, "would bring up the rear guard with a pickup truck and gather dead rabbits as we advanced through the sagebrush toward an irrigation canal where the rabbits would be trapped." When the frightened animals tried to escape by backtracking, added Jack, it looked

like the earth was moving. Coop sat on a hill at the edge of the drive, shooting rabbits at long range, with ammunition hand-loaded for his 2200 Lovell. Mr. Frieze and his sons collected more than 1,700 rabbits, selling the hides for five cents apiece and saving the hay crop. The family was quite appreciative and always treated everyone to a chicken dinner.[66]

Nor did Hem neglect his sons. Patrick Hemingway said his father was infinitely generous with both his time and his money and quite tactful in disciplining the boys. "I don't see how anybody could have been a better father. He…showed me…what a wonderful thing it is to read, enjoy the outdoors, and what an outstanding person is like."[67]

"I did a lot of hunting with Ernie in '40 and '41," remembered Bud Purdy, who said Hem never acted like a celebrity, was considerate of others and always wanted someone else to have the first shot. "And another thing.…I never once saw him drink while hunting." After the hunt, at dinner at the Ram, people sometimes wanted his autograph. "He never brushed them off. He was always polite. I never saw him rude."[68]

Clara Spiegel echoed the sentiments of both Patrick and Bud, saying that one day when she was in the car with Patrick and Gregory, about to go shooting, a lodge guest who didn't look good and had trouble walking came over and told Hem, who hadn't reached the car yet, that he was a real admirer of Hem's work. "Ernest took quite a little time with the man and he was very nice, telling [the man] that it was good of him to come over." After Hem shook hands with the man, he walked to the car, where the boys were giggling about the strange man. "There for the grace of God goes any one of us," he admonished the boys.[69]

The friendship between Hem and Coop was steady: "Papa and Coop talked a lot during lunch on our pheasant shoots," recalled Gregory, "for the most part casual conversation about hunting or Hollywood.…There was never rivalry between them, and there was no reason for any. They were both at their peak then."[70]

There was also a good deal of tennis playing, with Marty, Coop, Rocky and Hem enjoying frequent games of mixed doubles, the impeccable Coop decked out in white shirt, white sweater, white trousers and white shoes and socks. But the evening dancing, eating, drinking, joking and laughing and storytelling at Glamor House or the Trail Creek Cabin were the best. With the wine and the scotches and the conversations all flowing, the nights went on forever, with the word *war* not even mentioned.

In its November 24 issue, *LIFE* magazine offered a glimpse of all the fun with a four-page spread—and thirteen Capa photos—entitled "*Life* Goes

Hunting in Sun Valley with the Gary Coopers and the Ernest Hemingways." Photos of the two families were divided fairly evenly, but Coop clearly got top billing in this "picture," with the first and largest photo featuring him, a fly rod hoisted in one hand, tight-roping his way over a log straddling a stream. He was also seen grinning while flat on his back in an Idaho meadow ("Yep, I like to shoot, I like to fish, I like to lie in the sun"); stretching a strand of barbed wire to allow Slim Gross safe passage through a fence, her shotgun safely broken open, while Rocky and Hem assist; building a snowman with Rocky and Maria; and riding the chair lift with Maria up to the top of Bald Mountain, with the caption noting that Coop had taught his four-year-old daughter to sing "I'm an Old Cowhand" and "Home on the Range."

In his best supporting role, Hem was pictured navigating a canoe with Marty on Silver Creek, picnicking with Marty and Patrick and Gregory and hunting with Marty and all three sons. One caption mentioned that Marty had just published a collection of short stories entitled *The Heart of Another* (published by Scribner's). The independent Marty, however, wanted to make her own mark and would not have been pleased with the verdict that her writing was "much like Hemingway's."

Capa's most poignant photos in the *LIFE* spread were not of Coop and Hem or even of Coop and Maria but of Hem and Gregory ("Gig"), three weeks away from turning ten when the photos were shot, with images and captions that foreshadowed a complex relationship between father and son, one that would make each especially vulnerable to hostility from the other.

The two were seen reclining on a wooden bridge at Silver Creek after a successful duck hunt, Hem's deep feelings for his son evident. Other shots show the surprisingly gun-savvy youngster hunting ducks, but the last photo—of Gregory pouring his dad a drink of alcohol on the same Silver Creek bridge—portends trouble. Although the caption claimed that Hem's friends were amused at how Hem allowed his sons to drink beer and wine with meals "on the theory that they will learn moderation," Clara Spiegel, for one, was not amused and thought it was wrong of him to allow his boys to drink (although, as noted earlier, she thought Hem a good father "most of the time").

Hem and Gregory's later problems ran deep and involved a labyrinth of emotions and experiences; attempting to trace the effect of Hem's easygoing attitude toward his boys' drinking would miss the point (although twenty-first-century science unequivocally holds that *any* consumption of alcohol is dangerous for children). At the same time, in his relationships with his sons, Hem inevitably revealed how important manliness was to him, whether in

the form of hunting, big-game fishing, enduring seasickness (which Gregory was particularly prone to), enjoying bullfighting or cockfighting or—as would follow in a few years—trawling in a heavily armed "fishing boat" for German subs. The shot of Gregory pouring his father a drink portended trouble because "drinking like a man" fit right in with Hem's macho persona, a presence weighing heavily on his youngest son, who was already growing bewildered by life.

"I've spent hundreds of thousands of dollars trying not to be a transvestite," Gregory would tell author Paul Hendrickson many years later. He said his problems were threefold: "First, you've got this father who's supermasculine, but who's somehow protesting it all the time.…Second, you start playing around with your mother's stockings one day when you're about four years old…it must have something to do with the fact that your mother doesn't seem to love you enough." Third was a heightened awareness of the world around him. "You're a writer's son, after all."[71]

Gregory's early disquiet had not gone unnoticed by Hem. In a June 9, 1941 letter to Pauline, he said Gig had the "biggest dark side in the family except me and you" but kept that side concealed so that others would never know about it. Maybe it would disappear, Hem added. In his arresting and compassionate book *Hemingway's Boat*, Hendrickson speculated convincingly that such "hedgings and codings" indicate that Hem had recently found Gig "doing something horrid," something that Hem couldn't bring himself to candidly name. Gregory himself at least partially backed up such speculation by telling Hendrickson that his father once found him in the Finca's master bedroom putting on Mary's white nylons and by telling another interviewer that he was "about ten" when the discovery was made.[72]

Whatever his exact fears about Gregory, Hem put them to rest (although they would set off a firestorm between father and son a decade later). For now, *LIFE*'s depiction of the Coopers and the Hemingways in the pristine Idaho outdoors could almost make a person forget about the threat of worldwide conflict. Still, one glance at the *Boise Idaho Statesman* or the *Idaho Falls Post Register* made it impossible not to think about the war, not with news that the Soviets listed 2,122,000 men as killed, wounded or missing in the five months since the start of the German-Russian war; the Allies had been victorious in the first major clash in Libya; thirteen governments had now joined Nazi Germany in a show of solidarity against London, Moscow and Washington; and the United States had ruled out any chance of compromising on its severe economic sanctions of Japan because of that country's invasion of China.[73]

Most of the Sun Valley visitors, including Coop, Rocky and Maria and all three of Hem's sons, left in November. Hem was paying close attention to world news and was convinced that the United States would soon enter the war, even predicting that Japan would give America a "Christmas present," striking first in the Philippines. One morning Hem came up missing, and no one knew where he was. Marty and the Arnolds had begun to worry when Hem finally showed up. He had driven up to Trail Creek to walk alone along the water and through the trees and think. He told everyone he had decided that he and Marty had to leave immediately—"he said the smell of war was close."

On Wednesday, December 3, Hem and Marty loaded up the Continental and prepared to leave, planning to reach Cuba by way of Utah, Arizona, New Mexico, Texas, Louisiana, Mississippi, Alabama and Florida. Hem seemed to be all business, but Tillie, not knowing what the future would bring, was crying as she and Lloyd said their goodbyes. Then Hem hugged her, kissed her on the cheek and put a silver dollar in her hand. "Just so we'll never be broke, daughter," he said.[74]

Hem and Marty had been on the road for four days and were somewhere in Arizona when Hem's premonitions about the "smell of war" proved accurate. "We were drinking daiquiris in a mingy little bar on the Mexican border and talking about cattle-raising in Arizona," Marty wrote in 1959. "A tattered Indian Child came in with some clutched newspapers, and said '*Con la guerra, la guerra*' ["With the war, the war"] mildly. No one noticed him the first time around." Then Hem and Marty's curiosity was aroused, and they called to the boy. "He sold us a Mexican paper, damp with his own sweat. Smeary type announced Pearl Harbor and America's declaration of war."[75]

Hem was furious and in a letter written to Max Perkins a few days later freely expressed his anger (but not without instructing Perkins not to publish or circulate his opinions). He said that Charles Sweeney and John Thomason, two colonels he had talked to in Washington six months earlier, had both been sadly mistaken about Japan, adding that Secretary of the Navy Frank Knox should have been relieved of his duties within twenty-four hours of the disaster, but he saved his most bitter criticism for the military leaders at Oahu, whom, he said, should have been shot.[76]

Coop and Rocky were enjoying a pleasant Sunday in Brentwood, with temperatures in the mid-sixties, possibly learning of the attack on Pearl Harbor while listening to the CBS Radio Network:

*The Japanese have attacked Pearl Harbor, Hawaii, by air, President Roosevelt has just announced. The attack was also made on all Naval and military activities on the principal island of Oahu. We take you now to Washington: The details are not available. They will be in a few minutes. The White House is now giving out a statement....And just now comes the word from the President's office that a second attack has been reported on Army and Navy bases in Manila.*

The next day, President Roosevelt gave his historic "date which will live in infamy" speech. "With confidence in our armed forces," he said, "with the unbounding determination of our people, we will gain the inevitable triumph—so help us God."

One man who strengthened the nation's "unbounding determination" was Coop himself, by way of Alvin York. A few months earlier, the Veterans of Foreign Wars had presented Coop with its Distinguished Citizenship medal for his portrayal of Sergeant York. The film, quite popular since its summer release, was still going strong when the news about Pearl Harbor brought a new surge of ticket sales, reportedly inspiring many young male viewers to immediately enlist in the military.

Two years later, Coop would make his way to the South Pacific to befriend and encourage U.S. troops. Upon reaching Brisbane, in Queensland, Australia, he met General Douglas MacArthur, who told Coop he "was in a Manila theatre seeing *Sergeant York* when the bombs began falling."[77] But when Coop saw the soldiers themselves, who thoroughly appreciated his unpretentious personality, the one movie role they insisted on seeing was not that of the most famous war hero in America but rather of the humble, steady, Gary Cooper–ish first baseman of the New York Yankees.

# "THE LUCKIEST MAN"

In February 1942, Ingrid Bergman got bad news from David O. Selznick: Paramount Pictures had selected the beautiful ballerina Vera Zorina to play the part of Maria in *For Whom the Bell Tolls*. Nor had Howard Hawks been chosen to direct the film—that assignment had gone first to Cecil B. DeMille and then to Sam Wood, a respected director but also the last person in the world Hem would have wanted.

Ingrid was quite disappointed and thought one of the reasons purportedly given for rejecting her—that at five-foot-nine she was too tall—was ridiculous (and ironic indeed given that Coop was six-foot-three and Humphrey Bogart, her costar in *Casablanca*, five-foot-eight). Selznick, however, had urged her to look to the future, and she was doing her best to follow that advice.

Several weeks later, as shooting was wrapping up on *Casablanca*, Ingrid began hearing rumors that things weren't going well for Vera Zorina. Then came the official word that she was being moved to a different film. Selznick called to say that Sam Wood wanted to "test" Ingrid for the role, but it didn't involve acting—he just wanted to see what she looked like with short hair. So a studio photographer took a picture of her with her hair combed back and pinned up, and she waited anxiously to hear from Wood. The next day, Selznick called and said, "Ingrid, you are Maria." Within hours, she was driven 450 miles north to Sonora Pass in the Sierra Nevada Mountains.

One of the first people she met was a handsome man who came walking down the mountainside. "Hallo Maria?" he asked, and she blushed. It was Coop, of course, and Ingrid would call him "the most underplaying and

*Above*: Gary Cooper, *far right*, and high school friends in Bozeman, Montana, 1922. *Gallatin History Museum, Bozeman, Montana.*

*Left*: Gary Cooper cartoons and note on a high school scrapbook page, 1922. *Gallatin History Museum, Bozeman, Montana.*

most natural actor" she ever worked with. And she loved the role of Maria: "I studied everything Hemingway had written about the girl. I shut myself up for days just studying being that girl."

The cast and crew spent twelve weeks in the mountains during the summer of 1942 and another twelve weeks in the studio. Hem was keeping in touch with Coop and in an October letter to Patrick said that *For Whom the Bell Tolls* had almost been completed and there was talk of sending a copy to New York and having him fly up to see it. He added that Coop and Ingrid would both be good, regardless of how the rest of the cast turned out.[78]

The film was released in July 1943. The critics offered mixed reviews, but not the audience, which made *Bell* the most popular movie of the year.

Coop was nominated for the Oscar for best actor and Ingrid for best actress. (There were seven other nominations, but only Katrina Paxinou won, for best supporting actress.)

Ingrid saw Hem after the film was released (she didn't say exactly when) and initially thought he loved it because he said he had seen it five times. Then he explained that he disliked it so much that it had taken him five tries to sit through the entire movie. He added that none of his favorite scenes in the novel had been included in the screenplay.[79]

In January 1944, a young soldier by the name of Randon Gahlbeck wrote to his parents in Illinois: "Been in ten months and it seems a lot longer for there is nothing to tide us over the monotony. Day after day, the same old stuff....We see three movies a week for a little recreation....Gary Cooper and his troupe were over here. Gary's a swell guy."[80]

Coop had signed on for a USO entertainment tour of army, navy and marine bases in New Guinea with considerable trepidation because he thought he would flop trying to entertain a live audience. But Spencer Tracy, who had left on a tour feeling the same way, urged Coop to go. Coop finally said he would but added that he definitely would not sing. "Not sing!" exclaimed Tracy, "you have to sing—the worse you are, the more they eat it up."

So, with his schedule freed up, Coop made final arrangements for the November–December 1943 tour. Among those teaming with Coop were Una Merkel, forty-two—the same age as Coop—a Hollywood veteran who had made several movies a year since 1930, usually in "best supporting actress" roles; Phyllis Brooks, twenty-eight, who had worked steadily in B movies since 1934; and Andy Arcari, thirty-six, well on his way to becoming one of the leading accordionists in the country. They quickly got down to work, touring "camps and outposts in or near combat zones...regularly hearing blasts of gunfire or mortar," with conditions that "seemed more primitive with each succeeding stop [and going] a month without seeing a flush toilet." A typical schedule called for them to present a matinee show and then visit wounded and sick soldiers at the base hospital and conclude with an evening show. Jack Benny had given Coop several scripts he had used on his own USO tours. "I'd open the show with a few Benny and Hope gags and then we'd introduce the girls," Coop would tell the *Los Angeles Times*. "Then we'd do some comedy skits, Andy would play the accordion.... Finally, we all gave them 'Pistol Packin' Mama,'" a number-one jukebox hit recorded by Bing Crosby and the Andrews Sisters and sung to the tune of "Boil Them Cabbage Down":[81]

*Oh, drinkin' beer in a cabaret*
*Was I havin' fun!*
*Until one night she caught me right*
*And now I'm on the run.*
*Oh, lay that pistol down, Babe.*
*Lay that pistol down.*
*Pistol packin' mama*
*Lay that pistol down.*

The GIs cheered the show from start to finish, always greeting Una and Phyllis—who would tell jokes and sing songs like "I Cain't Say No" from *Oklahoma!*—with boisterous applause. "We were the first white women to go to New Guinea," said Una. "Some of the men had been there two years, and they didn't even have female nurses."[82]

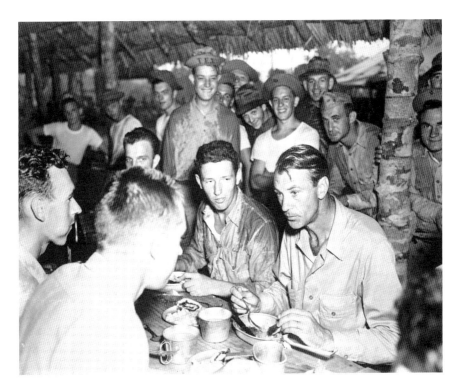

Gary Cooper eating with GIs during his USO tour of the South Pacific, 1943. *U.S. Marine Corps photo, Montana Historical Society Research Center, Archives.*

"One night we hit a small cloudburst," Coop later reported in an interview. "I thought the show would be called off and was dozing in my tent when an officer came in to say that 15,000 kids were sitting in the rain on a muddy slope waiting for us. We went out."

The troupe performed their entire routine and were starting it again when a voice in the crowd called out for Coop to recite the Lou Gehrig speech from *The Pride of the Yankees*, which had premiered the summer of '42. As posters for *Pride* proclaimed, this film told "the Great American Story" of "the Life of Lou Gehrig." Gehrig, who had played first base for the Yankees from 1923 to 1939, was humble and introverted (not unlike a certain actor) but strong and steady—dubbed "the Iron Horse." Most importantly for the Yankees, Gehrig was a tremendous hitter, every bit as good as the flamboyant extrovert teammate he had a hard time tolerating—Babe Ruth.

Lou's impressive career, as well as his record of playing in 2,130 consecutive games, screeched to a halt early in the 1939 season, when he took himself out of the lineup because of mysterious weakness that had sapped his strength. The diagnosis of amyotrophic lateral sclerosis (ALS, now commonly known as "Lou Gehrig Disease") was confirmed on June 19, his thirty-sixth birthday. On July 4, "Lou Gehrig Appreciation Day" was held at a packed Yankee Stadium, and Gehrig delivered a brief but heartrending farewell oration that came to be known as "the Luckiest Man" speech. Gehrig died on June 2, 1941; eight months later, the picture was being shot, with Coop, of course, playing Lou. The up-and-coming actress Teresa Wright played Gehrig's wife, Eleanor, and turned in a stellar performance. Walter Brennan also had a key role, that of Walter Blake, a sportswriter who becomes Gehrig's closest friend. The movie ends with Gehrig concluding his speech and then walking alone to the dugout, where he exits the glaring sunshine of the stadium and disappears into the dark dressing room.

Nothing more dramatic than Gehrig's last moments at Yankee Stadium ever occurred in a baseball stadium, but when documentary filmmaker Ken Burns was producing his acclaimed documentary *Baseball*, he encountered two difficulties. First, although more than one newsman was shooting film that July 4, no complete film of the speech has survived. Second, when pieced together through written and audio sources, the speech itself is not particularly compelling, despite the drama of the occasion. Lastly, the most powerful line in the speech—about being the luckiest man on the face of the earth—appears at the beginning of the real speech, not the end, where it would be most powerful.

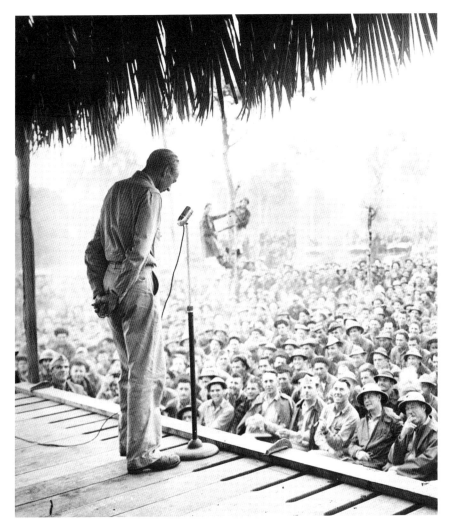

Gary Cooper reciting the Lou Gehrig "Luckiest Man" speech during his USO tour of the South Pacific, 1943. *U.S. Marine Corps photo, Montana Historical Society Research Center, Archives.*

Burns's solution not only made the speech more powerful and improved the flow of the scene, but it also served as a stirring memorial to both Gehrig and Coop. As the masterful narrator John Chancellor tells how sorrowful fans gathered for the tribute on July 4, improvisational pianist Jacqueline Schwab softly plays a mournful tune in the background, and we hear the noise of the crowd and see images of Lou walking onto the field, embracing his onetime antagonist Babe Ruth, being so overcome

with emotion that he can't speak and finally getting a gentle nudge in the direction of the microphones by his manager Joe McCarthy. The crowd rises to its feet and applauds. At the instant when Lou is about to speak, Burns cuts to the image of Gary Cooper, in Yankee pinstripes, standing at the microphones, the real Babe Ruth standing behind him and the crowd cheering, with the line "The Pride of the Yankees" appearing at the bottom of the screen. When the applause finally subsides, Coop speaks, and as he does, his words are echoed by the outfield speakers, just as they had been with Gehrig:

> *I've been walking on ballfields for sixteen years, and I've never received anything but kindness and encouragement from you fans. I've had the great honor to have played with these great veteran ballplayers on my left—Murderers' Row—our championship team of 1927. I've had the further honor of living with and playing with these men on my right—the Bronx Bombers—the Yankees of today. I've been given fame and undeserved praise by the boys up there behind the wire in the press box—my friends—the sportswriters. I've worked under the two greatest managers of all time—Miller Huggins and Joe McCarthy. I have a mother and father who fought to give me health and a solid background in my youth. I have a wife—a companion for life—who has shown me more courage than I ever knew. People all say that I've had a bad break. But—today—I consider myself the luckiest man on the face of the earth.*

At that point, the Burns documentary cuts back to the 1939 newsreel footage, showing the applauding crowd and Gehrig's concluding comments: "I might have been given a bad break, but I've got an awful lot to live for. Thank you."

Screenwriters Jo Swerling and Herman J. Mankiewicz had retained all the key elements of the original speech, deleted the nonessential material and restructured the text to give it considerably more motion and power. And rather than trying to imitate Gehrig by mimicking his speech patterns and expressions, Coop had offered his own interpretation, with his own pauses, glances and intonations that allowed both Gehrig and his alter ego to be considered and appreciated in a new light.

When the plucky soldier in New Guinea hollered, "Hey, Coop, how about Lou Gehrig's farewell speech?" *that* was the speech he was talking about. The men there had just seen *The Pride of the Yankees*, and they began to chant in unison for the speech.

Taken by surprise, Coop told the crowd he needed a minute to write down the words and make sure he didn't leave anything out. Meanwhile, the torrents of rain had not let up, with Coop getting drenched along with everyone else. When he was ready to give the speech, it was a "silent bunch" that listened intently. The word spread, and subsequent GI audiences along the twenty-four-thousand-mile tour requested and got the "Luckiest Man" speech.[83]

Coop considered his tour pretty insignificant compared to the sacrifices the soldiers were making. He had even tried to enlist not long after war was declared but couldn't pass the physical—largely because of injuries he had suffered making movies. Any contribution he could make was thus quite important to him.

After his return to the States, Coop reflected on his experience in the South Pacific:

> There's no coin in Hollywood, rich as it is, that can pay a fellow the way I've been paid for my little effort on behalf of the G.I.s out there. It was the greatest emotional experience of my life, meeting those soldiers in the mud, the rain, the jungle of New Guinea, and trying to reassure them that the folks back home are proud of them, and conscious to some extent of what they're doing for America. The boys are so appreciative of the slightest little thing you try to do for them, it's almost pitiful. You feel like bawling sometimes, and maybe you do a little, but you're happy at the same time. You're doing something really worth while, at least in the boys' opinion. Those kids'll be sitting out on a muddy hillside waiting for hours for the show to start. It can rain like hell, but they wouldn't think of moving an inch until it's over. Under those conditions, you rise above yourself and give it everything you've got.[84]

Rather than ending Coop and Hem's friendship, the war had merely interrupted it. A letter Coop wrote to Hem in the spring of 1945 shows he had been thinking about Hem frequently and felt as comfortable with him as always. He wrote the letter on May 1 and mailed it to Havana, apparently aware that Hem had returned to Cuba just six weeks earlier, after an adventure in England and Europe that lasted almost a year.

"Dear Ernesto," he wrote, "I have a hunch it's about time in the course of these events that you are cooking up something that will be of some great import to the literary field and to us out here and to me personally." He said he had learned a little since the last deal (*For Whom the Bell Tolls*) and that if a

Hemingway yarn were produced as a picture in the future, it would be great for Hem to be "here on the spot" (Hollywood) while it was being created.

Coop added that he had just finished a "western yarn" (*Along Came Jones*) that he had produced independently and would like to produce a film with Hem and share in the results. "If I am just shooting in the dark," Coop wrote, "would like to hear from you anyway. I've had various reports on your activities from time to time and all sound very interesting and weird." In closing, Coop said, "Many times Rocky and I have thought of the wonderful times we had at S.V. with you all. Maybe not too far in the future we can hash it all out up there again. Rocky and Maria are fine. We hope you're feeling in top shape, and our very best to you."[85]

Coop's not mentioning Marty by name may indicate that one of the "various reports" he had received concerned the sad state of the Hemingway marriage. As more than one researcher has noted, the best years of their relationship occurred from early 1937 to late 1940, *before* they were married on November 21, in Wyoming. It was all downhill after that, and in the spring of '42, she wrote in a letter to Hem that there would never be anything like their time together in Spain in '37.[86]

Hem's personal hygiene habits had been a source of conflict from the start. Slim Hawks had expressed an opinion common among those who knew him: "Ernest never seemed clean or bathed to me. His beard was scraggly. He'd wear the same clothes for five days."[87] That may have been an easy thing to tolerate when Marty and Hem were newly in love and surviving bombings and gunfire in Spain, but it was not at the Finca, where Hem was living a life of ease, with servants to deliver clean clothes and provide a spotless shower.

Second, although a highly versatile writer, Marty was a war correspondent at heart and deeply concerned about suffering in the world. Neither applied to Hem, although he could be quite compassionate in his personal dealings with people. After completing *For Whom the Bell Tolls* in 1940 and making the difficult trip to China with Mary early in '41, Hem, who was taking a break from writing, felt it was time for her to stay home and take care of her husband. That wouldn't happen with Marty. In July of '42, she left Cuba against Hem's wishes on an eight-week assignment with *Collier's* to explore how submarine warfare was affecting life in the Caribbean.

Another source of conflict: also in '42, Hem had, with the approval of the U.S. ambassador to Cuba, begun to use the *Pilar* to hunt for German submarines. By November, the *Pilar* was making armed patrols of Cuban waters. Marty scoffed at his "playing war" (even though she had helped

The old Shoshone Union Pacific Depot, which served Sun Valley visitors arriving or departing by train. *Photos by the author, 2016.*

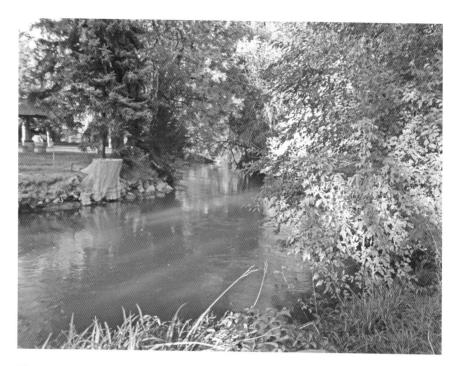

The Little Wood River flowing through the Shoshone City Park. *Photo by the author, 2016.*

arrange U.S. assistance through her friendship with the Roosevelts). Hem was quite justified in wanting to do something about the German threat, however, because U-boats were doing considerable damage in the area.[88]

In September 1943, Marty departed for England as a *Collier's* war correspondent. She had pleaded with Hem to go with her and use his great writing talent to help defeat Hitler. Hem refused, saying he was already helping the war effort, and "the quarrels became shrill and Ernest drank and grew more truculent. Gygi [Gregory], especially, was mortified when his father began to bait Martha, especially since it seemed to him that so often she was right and Ernest wrong."[89]

The patient Marty wrote frequently, always expressing her love for him but also urging him to come to England. "You will feel deprived as a writer if this is all over and you have not had a share in it," she wrote. "The place is crying out for you."[90] Hem responded with several letters saying he absolutely would not leave Cuba; he also wrote letters to Max Perkins and other friends saying he was terribly lonely without Marty. He continued to drink heavily.

Hemingway and Martha Gellhorn at Sun Valley, 1940. *Photographer unknown, Papers of Ernest Hemingway, Photograph Collection, John F. Kennedy Presidential Library and Museum, Boston.*

In January 1944, Marty traveled to the Italian front and, as she had in Spain, experienced firsthand the effects of the war, seeing horribly wounded and blinded men at aid stations. But Hem, who had praised Marty's articles in *Collier's* while talking with friends, said nothing of that to her, instead sending harsh cables, such as, "ARE YOU A WAR CORRESPONDENT OR WIFE IN MY BED?"

After six months away from Cuba, Marty finally returned in March 1944, first making sure that Hem would be there because she had been sensing hints that he would finally come to Europe. Stopping in Washington on her way home, she made contact with an official at the British embassy by the name of Roald Dahl and arranged a possible plane ticket to England for Hem in case he did want to go.

Her arrival in Cuba hardly resulted in the joyful homecoming she had imagined:

> *I was not received with loving tender care though I was absolutely exhausted....Ernest began at once to rave at me, the word is not strong enough. He woke me when I was trying to sleep to bully, snarl, mock—my crime really was to have been at war when he had not, but that was not how he put it. I was supposedly insane, I only wanted excitement and danger, I had no responsibility to anyone, I was selfish beyond belief....It never stopped and believe me, it was fierce and ugly.*[91]

Hem was clearly showing signs of the mental illness that would make itself so visible fifteen years later. Next, in a decision that likely involved his drinking, his rage at Marty for going to Europe and his inherited depression, Hem said he would indeed go to England, and he offered his services to *Collier's*, bullying his way into Marty's assignment (because each magazine was allowed only one correspondent on the front) when he could have chosen to represent virtually any newspaper or periodical in the country. "Therefore," said Marty, "I was totally blocked...having taken *Collier's* he automatically destroyed my chances of covering the fighting war [as an official war correspondent]."[92]

Marty was returning to England nevertheless, and she and Hem traveled to New York together, but his abuse continued. Although she had arranged for his plane ticket, he did not try to return the favor, telling her the flight was for men only, although she later learned that two women were aboard the flight.

If Hem or anyone else presumed that Marty's dreams of continuing her war reporting had ended, however, they didn't know Marty. She somehow managed to arrange passage as the only passenger on a freighter loaded with dynamite. The trip to London took two weeks, but she arrived unharmed.

Around May 22, while Marty was still enduring the freighter voyage, Hem had lunch at London's White Tower Restaurant and ran into Irwin

Shaw, a young playwright and screenwriter who was making a name for himself. Shaw was eating with an attractive woman. "Introduce me to your friend, Shaw," said Hem. After the introduction, Shaw's lunch companion later wrote, "Mr. Hemingway...shyly invited me to lunch the next day."[93]

# BACK TO SUN VALLEY

Hundreds of veterans were still at Sun Valley when Lloyd and Tillie arrived after Lloyd's stint in the U.S. Army Air Force, and they were lucky to find a house. They also heard the good news that the resort would reopen in December '46 and that Lloyd could work doing a variety of jobs in preparation for the opening. But there was also sad news: Taylor Williams's oldest son, Taylor III but called Tay, had been killed right toward the end of the war when he and several other men were machine-gunned to death while trying to escape a German prisoner of war camp. Lloyd and Tillie saw Taylor as soon as they could and did their best to console him.

Taylor had kept in touch with Hem during the war and brought them up to date. Hem and Marty had split up, and Hem was now living in Cuba with a war correspondent named Mary Welsh. They planned to get married as soon as the divorce from Marty was official.

Lloyd had barely got started with all the odd jobs he had to complete when word came that Coop and Rocky had called and asked if they could come up to hunt for ten days or so. They wanted to bring Rocky's uncle and aunt, Elliott and Irene Gibbons, with them, as well as Clark Gable and a lady friend. Despite the condition of the resort, Pat Rogers urged them to come. It was the perfect way to get Sun Valley back on track.

Jack Hemingway was the next guest. Like Taylor's son, he had been taken prisoner by the Germans, his confinement starting in October 1944. Hem—and Hadley and Paul—endured six months of worrying and waiting and hoping for the best. On April 2, 1945, Hem wrote to his friend Buck

Lanham that there had been no new word on Jack but that he had a hunch Jack would be okay. A week later, Hem wrote to Mary and said he had received a letter from Hadley listing the current address for sending a letter to Jack. With an Allied victory looking more and more inevitable, Hem felt Jack would be rescued soon. "Wouldn't that be wonderful?," he asked, at the same time acknowledging that they shouldn't count on it.[94] On May 8, the same day that V-E Day was declared, the wonderful news came that Jack had been safely freed from the prison camp.

Tillie wrote that Jack was in good spirits and told them about his "misadventures" during the war and also about Hem and Mary. Jack stayed for a week and a half and then headed to Missoula to attend the University of Montana. Then another call came from the Coopers, wondering if they could come up to ski in late February. Ingrid Bergman and her husband, Petter Lindstrom, as well as Clark Gable, wanted to join in, even though the hotels and ski lifts weren't open. Again, Pat Rogers appreciated their interest and said he would work something out.

By the time Coop and Rocky and Maria and the others arrived (in February 1946), Lloyd had found some cabins they could rent. He also took them to Dollar Mountain and showed them how to put seal skins on the bottom of their skis to make it back up the mountain after skiing down. They enjoyed the novelty and got proficient at using the seal skins. After a few days, the ski lift on Rudd Mountain became available, and Lloyd operated it. When Jack heard that Rocky and Coop were in town, he drove down from Missoula, and they all skied together. Lloyd took a photo that showed Jack, Ingrid, Coop and Clark, on Dollar Mountain, ready to ski down. Sun Valley used the photo for a press release, and it was widely published. Jack got to know Coop and Rocky better and ended up living with them for a time during the next few years. Their friendship proved valuable for a young man—and ex-prisoner of war—trying to find his way in life.

The whole group was still in Sun Valley in March when word came that Hem and Mary had gotten married in Cuba. Telegrams were exchanged, and everyone was thrilled when Hem said he and Mary would definitely come to Sun Valley in the fall. Early in the summer, Hem called again and asked Lloyd and Tillie to find a reasonably priced apartment that he and Mary could rent for three months starting September 1. He also said the boys would be coming about the same time.

On August 20, when the Arnolds knew that Hem and Mary were en route, another call came from Hem, in Casper, Wyoming. Sounding beside himself with worry, he said Mary had had emergency surgery and had almost died

Hemingway and Mary Welsh Hemingway at the Sun Valley Lodge, circa 1947. *Photographer unknown, Papers of Ernest Hemingway, Photograph Collection, John F. Kennedy Presidential Library and Museum, Boston.*

and was still in serious condition. It would be at least another two weeks before she could travel to Idaho. He asked about the boys, who had arrived not long before, and if Lloyd and Tillie could cover their expenses until he and Mary arrived. Lloyd assured him that everything would be okay on the Idaho end.

The one thing Hem didn't tell Lloyd—or Tillie when he talked to her a day or two later—was that he had saved Mary's life. In a letter to Buck Lanham, Hem explained that Mary had been pregnant since early July but there had been no sign of trouble. On Monday morning, August 19, as he was packing the car to leave Casper, Mary awoke in extreme pain. Hem rushed her to the hospital, where she was diagnosed with a tubular pregnancy that had burst. Heavy internal hemorrhaging caused a series of complications that convinced the anesthesiologist that her death was inevitable—apparently the surgeon was not yet on the scene. Hem, who had seen his share of battlefield transfusions and was always steady under pressure, took over the plasma administration, told the medical staff what to do and finally got the plasma flowing. Mary revived, the surgeon was able to operate and her life was saved. However, with one fallopian tube removed and the other possibly damaged, the chances of her ever being able to bear children seemed remote.[95]

Three and a half weeks later, Hem and Mary arrived in Ketchum. Keeping the attention on Mary, Hem carried her "like a doll" into the Arnold kitchen and set her in a rocking chair. She was tired and weak but in good spirits. Tillie said that within minutes, she and Mary were conversing like old friends. Hem seemed his same old friendly and courteous self, but he had gained considerable weight in the five years since Tillie and Lloyd had seen him. Luckily, he agreed to an appointment with the Sun Valley physician Dr. John Moritz, who put him on a diet and instructed him to cut way back on alcohol.

Coop, Rocky and Maria arrived a few weeks later. With them were Rocky's mother, Veronica Shields, Rocky's Uncle Elliott and Aunt Irene and good friends Ed and Gloria McLean. (The McLeans later divorced, and Gloria married Jimmy Stewart, also a good friend of Coop and Rocky.) Just as he had done with Lloyd and Tillie, Hem made Mary the center of attention, introducing her to everyone. Then Hem and Coop picked up right where they had left off in 1941, joking, talking about guns, making hunting plans and, in Coop's phrasing, "hashing it all out."

Hem learned that Coop's dad had died on September 18, 1946, at age eighty-one, although Coop said very little about how he felt about losing his dad.

Pheasant season had passed, but Coop and Hem got in some good duck hunting, sometimes taking others and sometimes just taking themselves and the dogs. The night life was good. The Coopers, Hemingways, Gibbons, McLeans, Arnolds, Rocky's mother, Taylor Williams and anyone else who

Two views of Craters of the Moon, called "Dante's Inferno" by Hemingway after he and Martha Gellhorn drove through the area at night in 1939. *Photos by U.S. Bureau of Land Management and the author.*

came along drank and talked and played blackjack and craps at the Club Rio or ate sumptuous dinners and drank and told stories at Trail Creek Cabin, with Hem and Coop unfailingly engaged and genuinely interested in whomever they were talking to.

The first fall together since 1941 was wonderful, said Tillie.[96] It was understood that the fall of 1947 would mark similar Sun Valley festivities. That happened, but in '47, something new entered the picture: political tension. Amazingly, the controversy centered not on Hem, who had had strong political motivations for creating the character of Robert Jordan, but on Coop, the non-political star who had played Robert Jordan strictly for professional and artistic reasons. Coop would weather the 1947 political football just fine, but the unpleasant episode served as a portent of a larger controversy that would surround the production of the film most closely linked with Coop: *High Noon*.

Coop was such a big star, with so much written about him in the gossip columns, that it was almost inevitable that his name would come up during the anti-Communist paranoia surrounding Hollywood in the 1940s and '50s. One story circulating in the spring of 1947 claimed that Coop had participated in the fight for independence in Spain (which sounds like Robert Jordan but not Coop) and that at a speech in Philadelphia he had praised Communism.[97]

The upshot of the widely circulated article was that Coop was called to Washington to testify as a "friendly witness" before the House Un-American Activities Committee (HUAC). He testified on October 23, 1947.

Calling him "Cooper," the chief investigator asked when and where he was born. In Helena, Montana, in 1901, came the reply. Occupation? Actor, said Coop, smiling. The questioning was then turned over to a Mr. Smith, who at least had the courtesy to address Coop as "Mr. Cooper."

Smith asked, "During the time that you have been in Hollywood, have you ever observed any Communistic influence in Hollywood or in the motion picture industry?"

"I believe I have noticed some," said Coop.

"What do you believe the principal medium is that they use [in] Hollywood or the industry to inject propaganda?"

"Well, I believe it is done through word of mouth," replied the low-key Coop. Mr. Smith asked him to speak louder.

"I believe it is done through word of mouth and through the medium of pamphleting—and writers, I suppose."

"By 'word of mouth,' what do you mean, Mr. Cooper?"

"Well, I mean sort of social gatherings." Smith asked for examples of Communistic statements Coop had heard at such gatherings. "Well, I have heard quite a few, I think, from time to time over the years," Coop replied. "Well, I have heard tossed around such statements as, 'Don't you think the Constitution of the United States is about 150 years out of date?' and— oh, I don't know—I have heard people mention that, well, 'Perhaps this would be a more efficient government without a Congress' [Coop smiled and waited for the laughter; it came], which statements," he added, "I think are very un-American."

"Have you ever observed any Communistic information in any scripts?"

"Well, I have turned down quite a few scripts because I thought they were tinged with Communistic ideas," said Coop.

"Can you name any of those scripts?"

"No, I can't recall any of those scripts to mind."

"Just a minute," interjected the chairman. "Mr. Cooper, you haven't got that bad a memory."

"I beg your pardon, sir?" said Coop, not taking the bait.

"I say," said the chairman, "you haven't got that bad a memory, have you? You must be able to remember some of those scripts you turned down because you thought they were Communist scripts."

"Well, I can't actually give you a title to any of them, no."

The chairman persisted: "Will you think it over, then, and supply the committee with a list of those scripts?"

"I don't think I could," said Coop, calm as ever, "because most of the scripts I read at night, and if they don't look good to me, I don't finish them, or if I do finish them I send them back as soon as possible to their author." A committee member by the name of McDowell asked if that were the custom of most stars. "Yes, I believe so, yes, sir. As to the material, which is more important than the name of the script, I did turn back one script because the leading character in the play was a man whose life's ambition was to organize an army in the United States, an army of soldiers who would never fight to defend their country. I don't remember any more details of the play, but that was enough of a basic idea for me to send it back quickly to its author."

No one asked if he remembered the name of that author. Smith now took up the questioning again: "Mr. Cooper, have you ever had any personal experience where you feel the Communist Party may have attempted to use you?"

"They haven't attempted to use me," answered Coop, now fiddling with his watch, "I don't think, because, apparently they know that I am not

very sympathetic to Communism." Coop then told of "chit-chatter" about Communism at parties, statements praising Communism and a strange tale of a supposedly Communist actor who had a luxurious house in Moscow. "It looked to me like a pretty phony come-on....From that time on, I could never take any of this pinko mouthing very seriously, because I didn't feel it was on the level."

Smith next asked Coop to read a document obtained through the State Department that showed "that the Communist Party attempts to use actors individually throughout the world to further their cause."

Coop was handed a document. He read, "Gary Cooper, who took part in the fights for the independence of Spain, held a speech before a crowd of 90,000 in Philadelphia on the occasion of the consecration of the banner of the Philadelphia Communist Federation. Between other things, he said: 'In our days it is the greatest honor to be a Communist. I wish the whole world to understand what we Communists really are.'"

Smith asked if Coop had ever been in Philadelphia.

"No, sir, I was never in Philadelphia."

"Do you have any comment to make regarding this letter?" asked Smith.

"Well," said Coop, "a 90,000 audience is a little tough to disregard, but it is not true."

"I want to help you along, Mr. Cooper," said the chairman.

"No part of it is true, sir," said Coop.

The chairman said the committee knew it was "just a plain, ordinary, ruthless lie."

McDowell posed another question: "And also, Mr. Cooper, in order to get it into the record, don't you think there wouldn't be 90,000 people in Philadelphia who were Communists?"

"Well," said Coop, "I believe it was Mr. Smith here that said you would have a hard time getting 90,000 people out in Philadelphia for anything [which brought laughter from just about everyone except the most humorless committee members]. I don't know about that."

The lead investigator jumped back in: "Mr. Cooper, witnesses who have preceded you from Hollywood have said that they consider members of the Communist Party to be agents of a foreign government. Do you consider the members of the Communist Party to be that?"

"I am not in nearly as good a position to know as some of the witnesses that have been ahead of me," replied Coop, "because I am not a very active member in our guild. They, therefore, know much more about the politics and the workings of what Communists there are in the guild than I. From

the overall things that you hear in Hollywood, I would assume that there is such a close parallel."[98]

And so it went. Newspapers the next day simply reported that Gary Cooper had "turned down Red scripts" or that he had "rejected one movie role because it was about an 'Army whose members would not fight.'" There was no criticism of Coop for not specifically naming scripts or writers.[99] But Sam Wood, a virulent anti-Communist, was quite critical of Coop for not naming names (ironic after Coop had gone out of his way to defend Wood from Hem's criticism). Historians and commentators have debated whether Coop was naïve, crafty or a little of both.

"The most pointless testimony," wrote one, "came from Gary Cooper... whose appearance in double-breasted suit, light blue silk necktie, and white shirt brought sighs from the spectators."[100]

Perhaps Coop's biographer Stuart M. Kaminsky said it best: "Although he was an outspoken Republican...who cooperated quite fully with [HUAC], he never gave that committee a single name it could follow up on, nor did he cite a single script he had ever seen that could get anyone into difficulty with the committee. In fact, his testimony before that committee is so amazingly true to his screen persona that it is difficult to tell if Cooper was acting or really unable to remember the scripts and names."[101]

Wasting no time, Coop flew back to Hollywood and finished a few odds and ends required for the final shooting of *Good Sam*. In early November, he and Rocky and Maria headed to Sun Valley, where Hem and Toby Bruce had arrived in a new Buick Roadster late in September. Mary, who had come separately, reached Sun Valley just a little ahead of the Coopers and had learned of Coop's HUAC testimony while she was in transit. She wasn't happy about it, likely believing that Coop's agreeing to testify as a friendly witness tended to lend legitimacy to the disgraceful actions of the committee, whether or not he named names. Never shy about being outspoken, Mary told Coop exactly what she thought. While not defending his HUAC testimony specifically, Coop said, in his unflappable manner, that Russian Communism was a real threat. What really galled Mary was that Hem refused to be hard on Coop, even though she knew Hem had a healthy contempt for the HUAC and everything it stood for.

The storm blew over, and at Thanksgiving Mary flew to California to spend some time with Pauline—who had become a friend—and Patrick and Gregory. After her return, the subject didn't come up again. Neither Lloyd nor Tillie mentioned it at all.

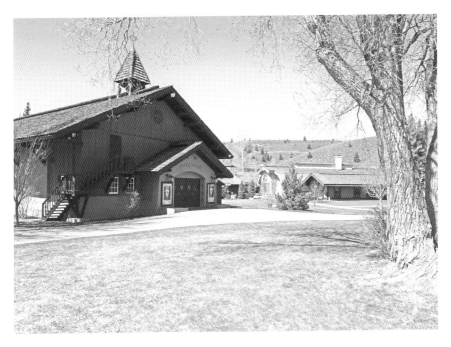

The Sun Valley Opera House, where Mary sang with a local choir on Christmas Eve 1947. *Photo by the author, 2016.*

All in all, it was another good fall, with Mac and Nin McCrea, Clara Spiegel, Slim Hawks, Taylor Williams and a host of others on the scene. Hem and Coop hunted in the marshes of Silver Creek, in the fields near Shoshone and in the wilderness near Craters of the Moon. They even went southwest to the Glenns Ferry area to get a look at the Idaho section of the Oregon Trail.[102]

Things were going so well that several of the friends, including the Hemingways and Coopers, decided to stay through the Christmas holidays. All three of Hem's sons arrived, as well as two of Hem's friends from Cuba. Mary sang in a local choir and loved it. The presence of friends and family was particularly meaningful to Hem, still smarting from the deaths of Max Perkins and lifelong friend Katy Dos Passos just months earlier. Lloyd shot one of his most memorable photos on New Year's Eve 1947: Hem, movie producer Henry Hathaway, Coop and Ingrid Bergman engaged in what appears to have been a fascinating conversation. As far as is known, it was the first and only time that the writer and two co-stars of *For Whom the Bell Tolls* were together.

There would never be another autumn and winter like the one in '47.

CHAPTER 5

# THE END OF THE AFFAIR

On October 8, 1948, the cast and crew of *The Fountainhead*, a film based on Ayn Rand's "best-selling 754-page potboiler [dealing] with corporate corruption, sex, and the ultimate triumph of the individual over the masses," held a wrap party to celebrate the project's completion. Among those present at the soiree were Hollywood heavyweights King Vidor, the director; the star, Gary Cooper; his male co-stars, Raymond Massey and Robert Douglas; and the young starlet Patricia Neal. As the evening drew to a close, Coop and Pat Neal lingered, and with the crowd thinning, Coop asked if he could drive her home. She answered that she had her car but that he could follow her.[103]

Two months later, in Italy, with Mary elsewhere, Hem accepted an invitation from Count Karl Kechler for a weekend of duck hunting at a private game preserve. The count had also invited another friend, a young woman by the name of Adriana Ivancich, to join them. When the count and Hem pulled up in a chauffeur-driven Buick sedan, Adriana climbed in the back of the car with Karl, who motioned to the man sitting in the front. "By the way, do you know Ernest, Ernest Hemingway, the writer?" In a letter to a friend, Hem described Adriana as a "beautiful, jolly, nice, and ungloomy girl."[104]

Coop, who hadn't had a popular and critical hit since 1943's *For Whom the Bell Tolls*, was forty-seven and Pat twenty-two. Hem, who hadn't published a novel since 1940's *Bell*, was forty-nine and Adriana eighteen.

Coop's romantic life both before and after his marriage to Rocky had been a standard topic of Hollywood gossip for years. His relationships with the actresses Clara Bow and Lupe Velez and the Countess di Frasso

One of Gary Cooper's movies featured at the only theater in the rough-and-tumble mining town of Wallace, Idaho, circa 1951. *Historic Wallace Preservation Society.*

had been public knowledge, with all three acknowledged by Coop himself. And while his biographers unanimously conclude that he was unfaithful to Rocky after their marriage, those conclusions are based on hearsay and indirect evidence. His relationship with Pat, however, would soon become quite public.

"In all of Cooper's hinted postmarital romances," wrote one biographer, "none had involved a girl who wanted to get married." Nor did Coop criticize Rocky in Pat's presence or try to play the "my wife doesn't understand me" card.[105] Not only that, but when her relationship with Coop had long been in the rear-view mirror, Pat would write, "No matter what his biographers say about [Coop's] philandering, I do not believe he ever intended to use a woman badly."[106]

Hem's infidelity, by contrast, was quite a different type. His relationship with Adriana was never sexual—only because Adriana showed no interest in such—but that actually complicated the situation because he was unfaithful just the same, and there could not be a clear "end of the affair."

When Hem asked Adriana to meet him and others for a drink, Adriana's mother, Dora, was alarmed, but Adriana insisted Hem wanted to introduce her to his wife. The meeting was indeed innocent enough, with Mary paying little attention to Adriana, just noticing that she was respectful and Hem was already calling her "daughter." Hem saw Adriana more than once in the coming weeks, always in the company of friends, and she reassured her mother that the relationship was innocent.[107]

Coop would stop by Pat's apartment a few times a week, sometimes with flowers or wine and frequently with something for Pat's neighbors, Jean Valentino and her roommate, Chloe Carter. Pat knew she had no rights with Coop and tried not to consider the possibility of his divorcing Rocky and marrying her. Instead, she savored the moment, enjoying the way he lit tipped Parliament cigarettes and handed one to her or made himself the butt of funny stories. Coop even took Pat to see his mother, who apparently considered them to be strictly friends. Jean and Chloe were the only ones who knew the truth, wrote Pat. "They never questioned our relationship, and Gary and I never questioned theirs…knowing we were all in murky waters."[108]

Pat had signed on to co-star with Richard Todd and Ronald Reagan in a film called *The Hasty Heart*, and she left in early December for shooting in England. She and Coop had a clear understanding: there were no promises. She wrote Coop (in care of Jean and Chloe) almost daily and frequently talked to him by phone. Coop also sent several letters, an unusual practice for him. Pat ended up spending quite a bit of time with "Ronnie" Reagan, who became a good friend.

On January 21, in Cortina, Italy, Mary broke her ankle skiing. One thing followed another, and Hem was soon in bed with a bad cold; in mid-March, he spent ten days in a Padua hospital receiving large doses of penicillin for an infection to his eyes and face diagnosed as erysipelas. He and Mary finally made it back to Venice at the end of March. Mary had now recovered enough to visit her favorite museums. But not with Hem. He was again finding ways to see Adriana, and when he met her brother, Gianfranco, who had been wounded in the war and was now trying to find his way, he immediately befriended him. Then Hem discovered the coincidence that Gianfranco had applied for a job in Cuba. Hem promised Adriana she could count on him—he would look after her brother in Cuba.[109]

Between fighting a bad cold and an eye infection, Hem had also done something else: he had started a new short story. It told of an aging American soldier on a duck-hunting trip in Italy who was infatuated with an eighteen-year-old girl from Venice.

Pat Neal had turned twenty-three the day before Mary broke her ankle. A few weeks after that, she arrived in New York to stay with friend Jean Hagen at her apartment. But when a knock came at the door, it was Coop, who had planned the surprise with Jean. Back in California, Pat and Coop settled into their old routine, but Pat later wrote, "It was becoming very hard to contain my longings for a family of my own with a man who would love only me."

About that same time, Kirk Douglas began asking Pat out. He was her escort to the premiere of *The Fountainhead*. There had been high expectations for the film from the start, but Pat had premonitions that things wouldn't turn out well, feelings confirmed when the movie ended and she saw members of the audience looking in the other direction when she got close. Not only was the reception cool that night, but critics also soundly criticized both the script and the acting.

On another date, Pat and Kirk returned to Pat's apartment after dinner and had a drink. Pat found him quite attractive and responded to his passionate kisses but drew the line at kissing. After Kirk left, the doorbell rang, and Pat found Coop standing there. He said he had looked through the window and had seen what was happening between her and Kirk. But *nothing* had happened, thought Pat, and as she started to smile, Coop slapped her. She put her hand to her face, and it came back with a touch of blood. "You don't do that to me," she said, shocked he had done something so totally unlike him. Coop was immediately contrite and apologized, asking her to forget what had happened. She never mentioned it, nor did it happen again.[110]

Hem and Mary were back in Cuba by the end of May 1949. Hem was now separated from Adriana, but he was likely thinking about her constantly as he worked steadily on the story that had now become a novel entitled *Across the River and Into the Trees*. Hem turned fifty in July, and the protagonist of the novel, the grizzled U.S. Army colonel and World War II veteran Richard Cantwell, is also fifty. The present action of the story takes place on a Sunday in a marshy duck blind, as Cantwell, who knows his death from a heart condition is imminent, reflects on his life and his love for Renata, a character conspicuously based on Adriana. The two have apparently had a sexual relationship, although such is not expressly stated in the narrative.

In September, a young writer by the name of Aaron Hotchner, soon called "Hotch" by Hem, arrived in Cuba representing *Cosmopolitan* magazine and asking Hem to submit an article. Instead, Hem eventually agreed to allow the magazine to publish his new novel in serial form before it was published by Scribner's.

Once again, Hem stayed away from Sun Valley and made plans for Europe. After Mary visited her parents in Chicago in late September and early October, she and Hem sailed for France on November 19. Hem finished *Across the River* on December 10, and Hotch arranged typing of the final revisions. Hem and Mary traveled to Venice at the end of the year, and early in 1950, Hem saw Adriana.

In the summer of '49, not long after *The Fountainhead* was released—and as Hem was hard at work on *Across the River*—it was looking like neither Hem nor Coop would frequent Sun Valley again. Coop had purchased property in Aspen, essentially the Sun Valley of Colorado, and decided to have a beautiful home built there. It was just being completed in July.

Pat had just learned that she would be co-starring with Coop in *Bright Leaf*, but that good news also brought a bad omen. When she read the script, Pat loved the character named Sonia Kovac, a warm, honest woman, and disliked the character Margaret Jane Singleton, manipulative and unloving. She wanted Coop to help her get the role of Sonia, but he refused, wanting to avoid conflicts with the producer and director. Pat was furious when she was assigned the part of Margaret and Lauren Bacall got the part of Sonia, as well as top billing with Coop.

Coop's publicist, Harvey Orkin (who didn't know about Pat and Coop's affair), had become a good friend of Pat's. One day, as he and his girlfriend, Helen, were having lunch with Pat, Harvey said it would be a great idea for them to all go to Aspen to hear the great physician and humanitarian Albert Schweitzer speak. The group would include Pat's mother, who happened to be visiting. Pat could hardly say no, but she knew some extremely uncomfortable moments with Rocky could easily result.

A few days later, in Aspen, after Rocky had taken the group for a tour of the skeleton of the new home, Pat and her mother and Harvey and Helen returned to their hotel for the night. The next morning, Harvey drove Pat to the hotel where Coop and Rocky and Maria were staying. Coop was sitting in the work truck and did not get out to open the door for Pat, as he always did. Pat got in the truck and sat down next to Coop. Before either of them could speak, Pat saw Rocky and Maria walking by. "Rocky's face was like stone," Pat would write. "Maria's was stained with tears. The child looked at me and spat on the ground."

The previous night, Coop explained, Rocky had asked him if he were having an affair with Pat. Yes, he said. She next asked if he were in love with Pat. Yes, he said again. At that moment, Maria came into the room, and Rocky told her everything.

Pat could not imagine how Rocky could do that to her own daughter. "I never understood until I heard myself blurt out the same wounding message to a daughter of my own, twenty-five years later," she wrote.[111]

Early in 1950, Adriana saw Hem frequently. Mary felt Hem was entangling himself in a situation that would only bring him pain but also knew any advice from her would fall on deaf ears. When Adriana needed a ride from Cortina to Venice, Hem volunteered to drive her. Mary stayed behind and continued skiing with an instructor but broke her left ankle in a fall. When she saw Hem again, he said he wanted to invite Adriana and Dora to Cuba. Mary reluctantly agreed, and Dora, still skeptical of Hem and Adriana's relationship, thanked them but made no commitment.

Adriana was a good artist and had earlier submitted a sketch to Scribner's as the proposed cover art for *Across the River*. Now came word that her sketch had been selected over quite a number of others submitted, with the decision made before anyone at Scribner's knew of her friendship with the author. To celebrate his "partnership" with Adriana, he hosted a luncheon the day before he and Mary were scheduled to leave for Paris. Afterward, he invited Adriana to take a walk with him. With Adriana paralyzed with fear, he said, "I would ask you to marry me, if I didn't know that you would say no," talking marriage with her just as he had with Mary long before he and Marty were divorced. Adriana smiled but said nothing; Hem suggested they now walk along the Seine and said nothing more about a proposal.[112]

Pat and Coop's affair continued throughout 1950, but he would occasionally remind her he was too old for her and also expressed his worries about Maria, saying the ongoing affair was obviously worrying her considerably. Their incredibly busy schedules were also adding stress: Pat was scheduled to shoot *The Breaking Point* (based on Hem's novel *To Have and Have Not*) in April and May, Coop *Dallas* from May to June and *The Big Country* throughout the summer, Pat *Raton Pass* from July to August and *Operation Pacific* from August to October and Coop *You're in the Navy Now* in November and December. Nor could Pat ever forget that Coop still had a family life. Early in April, he and Rocky flew to New York to see Hem and Mary, who had just arrived from France. The two couples had dinner at the Stork Club.

On July 1, hitting rough seas aboard *Pilar*, Hem suffered a severe concussion. But the blow that hurt him worse came in September, when the critics got their hands on a copy of *Across the River and Into the Trees*. As James M. Hutchisson summarized: "Morton Zabel called it feeble and dull in the *Nation*....Alfred Kazan lamented that such an excellent writer had produced

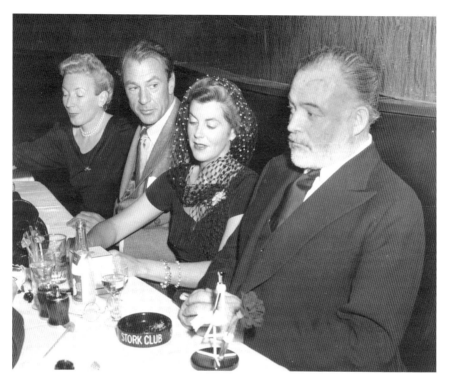

Mary, Gary, Rocky and Ernest at the Stork Club in New York City, April 3, 1950. *Montana Historical Society Research Center, Archives.*

such a poor work late in his career....Northrup Frye remarked that the novel was similar in theme to Thomas Mann's *Death in Venice* but that Hemingway's attempt was amateurish compared to Mann's."[113] The book was an instant bestseller, but that was no consolation for the bitter Hem.

Within weeks, Coop took a blow himself: Pat told him she was pregnant. Pat wrote that Coop wanted her to have the baby. As he held her hands to his cheeks, they felt love and wonder between them. But the next morning, Pat wrote, reality had set in, and she was wracked with worry about her career and especially about how her mother would react. She asked Coop what they should do, hoping, in her words, that he wouldn't "drop the curtain." Coop said he wasn't sure what to do but knew someone he could ask. She said that was good, not believing it was good at all.

Coop made an appointment with a doctor and drove Pat to a shabby office building. She went in by herself and handed the doctor an envelope full of cash. No one in the office said more than was absolutely necessary.

Pat called it the most agonizing hour of her life. "All I could hear was the sound of scraping." Back in her apartment, Pat lay in Coop's arms as they both cried. And, wrote Pat, "for years and years I cried over that baby. And whenever I had too much to drink, I would remember that I had not allowed him to exist."[114]

About that same time, Mary wrote to Charles Scribner that she had decided to leave Hem because of his abusive treatment. Why she did not is not clear—perhaps to give Hem one more chance to choose her over Adriana, who was scheduled to arrive in Cuba with her mother at the end of October. Mary welcomed Adriana and Dora, who had a touching reunion with Gianfranco, and did everything possible to make them comfortable, but she wouldn't have known it from Hem's continued harsh treatment. He was, of course, delighted to see Adriana and began talking of their partnership again. It was not unusual for Hem and Mary to have long-term guests, and the Ivanciches were no exception: they were scheduled to stay for at least a few months. Then, with 1950 drawing to a close, word came that Coop was bringing Patricia Neal for a visit. When they arrived at the Finca, Hem rushed out to meet them, greeting Coop with outstretched arms, thumping him with playful punches and hooting. Mary's reception was reserved, almost unfriendly, and Pat knew Mary was a loyal friend to Rocky. But Pat had no doubt that Hem liked her. Never one to compliment films made from his books, he told Pat *The Breaking Point* was the best picture of any based on his books.

Pat felt certain that Coop was seeking Hem's advice about whether he should leave Rocky and marry Pat. She felt just as certain that Hem gave his blessing. Of course, Coop and Pat also met Adriana and her brother and mother. There was good wine and good conversation, but something happened that irked Hem and pleased Mary. Adriana could not hide the fact that she found Coop tremendously attractive. As the weekend progressed, she was paying less and less attention to Hem, who must have breathed a sigh of relief when his pal was gone.

It soon became evident, however, that Adriana would be irreparably harmed by Hem's novel. As soon as *Across the River and Into the Trees* was published, readers and critics alike—so used to Hem writing autobiographical fiction—began wondering who the real-life Renata was. Cantwell was immediately assumed to be a combination of Hem and his friend Buck Lanham, and many assumed Adriana to be the foil for Renata.

Hem had made sure that the book would not be published in Italy for at least two years, but copies soon made their way there regardless, and

gossip about Adriana rapidly made its way through Venice. The gossip was often salacious because Adriana was presumed to have had an affair with Hemingway—didn't Cantwell and Renata make love in a gondola under a blanket? Dora had warned Adriana that these kinds of things might happen, but Adriana tried to shrug it all off. She could no longer do so when Dora showed her a French newspaper featuring a large photo of her with the caption "Renata, Hemingway's new love."

"And that was how it ended," wrote Bernice Kert. Dora and Adriana promptly moved to a Havana hotel. Then, although they had planned a trip to the American Gulf Coast with Hem, they went instead with Mary on February 7. A week later, they departed for New York, and a week after that, they set sail for Europe. It had ended, but Hem persisted, writing Adriana almost one hundred letters over the last ten years of his life, time and again expressing his undying love for her.[115]

In hindsight, Pat Neal concluded that her love affair with Coop was actually doomed about the same time that Hem lost Adriana (just one of several ways in which the writer and the actor seemed to keep time with each other). Early in 1951, Coop informed Pat that he had told Rocky about Pat's abortion. Pat wrote that if she had been older and wiser, she would have realized that Coop never would have told Rocky unless he intended to stay with her. The immediate upshot of Coop disclosing this information, however, was that he and Rocky separated.

*At last*, Pat thought to herself, but instead of making arrangements to live with Pat, Coop moved into the Hotel Bel-Air, another signal of his plans for the future. He began living a dual life—part family man, part bachelor. Of course, his separation from Rocky and Maria soon became public, and the word quickly spread that Patricia Neal had broken up Gary Cooper's marriage. Coop was also cast in a negative light, but the double standard of the day made Pat the chief troublemaker. The press followed her everywhere, even to movie sets, but she refused to speak to them. She found herself losing a chance to appear in a Eugene O'Neill play and being uninvited to parties because of the constant talk of her being a homewrecker.

Late in the year, before making a trip to New York, Coop said he would call Pat after he arrived. She waited for the call, but when it came, Harvey Orkin was on the line, telling her Coop was in the hospital, apparently with ulcers. She called the hospital, got Coop on the line and said she would drop everything and fly to New York. Coop didn't want her to come, insisting she stay in California. Pat was at first worried about him and said she couldn't see him, but all of that eventually turned to anger that she couldn't be with

the man she loved when he needed her. Thinking that Coop's mother could help her, she called Alice and said she desperately needed to see her. Alice was astounded that Pat would have the nerve to call her and said Pat was the reason Coop was sick in the first place.

Deeply hurt, Pat admitted to herself that she well could have caused Coop's declining health and that she would never have a husband—or a baby—with him. She immediately called him back and said she could never see him again. She heard only silence and asked if he had heard her. "All right," he said, "if that's what you want." She said it was what she wanted. Then she hung up.[116]

# "STILL IN DANGER OF DYING"

On a pleasant day in late January 1954, Coop, Rocky and sixteen-year-old Maria got in their car and drove southwest toward the Pacific Coast Highway. Decades later, Maria described what happened next: "We were in the car going up to the surfing beach, and we had the radio on, and all of a sudden this news bulletin came on that Ernest Hemingway and his wife were in a plane crash in Africa. My father almost swerved off the road he was so upset—shocked. Then he desperately tried to call any place he could think of to find more news. The next day my father finally got a hold of Jack, and the two of them stayed in touch over the next period of time"[117] and communicated with Patrick, who flew to Africa and chartered a plane to reach Hem and Mary.

Hem and Mary had been on a safari since August 1953; Coop had been invited but had opted out because of his film schedule. The variety of news reports about the plane crash published in a single day, January 25, offer a glimpse of what Coop likely encountered as he tried to discover if Hem and Mary were still alive and, if so, whether they were seriously injured.

With a dateline of "Kampala, Uganda, Jan. 24," the front-page banner headline "Fear Hemingway Killed in Crash" was typical of the initial reporting, followed by the subtitle "Smashed Plane Sighted on Bank of Nile River." The wreckage of his plane had been spotted from the air in a tropical country inaccessible by ground. No signs of life had been seen. Hemingway and Mary had been on safari, and a search had been launched after their plane had failed to make a scheduled stop.

As further reports trickled in, most headlines looked something like this: "Hemingways Plane Crashes: Africa Jungle Conceals Fate of Author, Wife." A British pilot, Captain R.C. Jude, who had circled the area three times said the craft was damaged only slightly. "One wheel of the undercarriage was broken, but otherwise the plane appeared little damaged." Jude added that he saw the identification letters on the plane very clearly. Still, there were no signs of life.

Late-edition newspapers were overly optimistic: "Hemingway, Wife Survive Two Jungle Plane Crashes," with the first paragraph summing up: "Ernest Hemingway, 55 [actually fifty-four], one of the world's greatest living writers, was on his way back to civilization by car today after surviving two [correct] week end jungle plane crashes without injury [incorrect—he was actually seriously injured in the second crash].

In his 1969 biography of Hem, Carlos Baker would fill in details largely unknown until then. From January 21 to January 23, a pilot named Roy Marsh had flown Hem and Mary on a series of flights over some of the most spectacular country in Africa—the Serengeti Plain in northern Tanzania and parts of the Belgian Congo and western Uganda along the White Nile River. Mary had shot hundreds of photos. She also wanted to take pictures of Murchison Falls, and Roy circled low; when he dropped farther to avoid a flock of ibis, he nicked an old telegraph wire, plunged down and made a successful crash landing. Roy and Hem and Mary all got out safely, but Mary was in shock and had to lie down. Hem had a sharp ache in his chest and a sprained right shoulder.

Fearing they might be trapped in the wilderness for days or weeks, they rejoiced the next day when a riverboat appeared and offered them passage to Butiaba, but at an astronomical rate. There a bush pilot offered to fly them to Entebbe, but as he started to ascend from the rough dirt runway, the plane crashed back down and burst into flames. The pilot, Roy and Mary scrambled out of the plane, but Hem was trapped and could only escape by butting the jammed door open with his head and injured shoulder.

Hem and Mary, limping from an injured knee, were taken fifty miles by car to a larger town, where they got brief medical attention. Then it was another hundred miles on dirt roads to the Lake Victoria Hotel, where they got food—and alcohol—but very little rest because of the government officials and horde of reporters anxious to interview them. Hem acted like he was okay but, wrote Baker, "[h]e was still in danger of dying. Apart from the full-scale concussion, his injuries included a ruptured liver, spleen, and kidney, temporary loss of vision in the left eye, loss of hearing in the left ear,

a crushed vertebra, a sprained right arm and shoulder, a sprained left leg, paralysis of the sphincter, and first degree burns on his face, arms, and head from the plane fire."[118] Hem would never be the same again.

Things had been so different a year earlier, with both Coop and Hem rebounding from a several-years-long slump in a remarkable way. On March 19, 1953, Coop had received the Oscar for best actor at the Academy Awards for his portrayal of Will Kane in *High Noon*. Less than seven weeks later, Hem won the Pulitzer Prize for *The Old Man and the Sea*. At ages fifty-one and fifty-three, respectively, Coop and Hem were right back on top. A week after the Pulitzer announcement, *Look* offered Hem $15,000 in expenses for an African safari and $10,000 for a related article. He and Mary sailed for Europe late in June, the same week that Coop, Rocky and Maria had an audience with Pope Pius XII in Rome. In July, Coop and Hem saw each other in Paris, and Coop expressed his regrets about having to miss the safari.

While Coop's performance in *High Noon* was widely praised, nothing could match his personal acts of loyalty to a friend during the production of the film. A new round of HUAC hearings had begun in June, and the committee had set its sights on Carl Foreman, co-producer and writer of the picture, who had joined and resigned from the Communist Party several years earlier. Writing the script after he had been subpoenaed by the committee, Foreman wrote *High Noon*, as he explained in a letter, "as a parable of what was happening in Hollywood....I became the Gary Cooper character."

When Coop, recently signed on for the film, learned what was happening, he told Foreman he would back him. Foreman wrote, "Cooper put his whole career on the block in the face of the McCarthyite witch-hunters. [After Foreman's subpoena became public knowledge], Cooper was immediately subjected to a violent underground pressure campaign [led by the likes of John Wayne and Hedda Hopper] aimed at getting him to leave the film, and he was told that unless he agreed to do so, he, too, would be black-listed.... But Cooper believed in me. He saw it through." Director Fred Zinnemann, a good friend of Coop's, and Coop both had a chance to back out, but neither did, added Foreman. "They were quite wonderful. They were, if you will forgive me, real Americans."[119]

Coop took extra pleasure in his and Zinnemann's and Foreman's nominations for Academy Awards (only Coop won), but he did not have the pleasure of sharing the win with Rocky and Maria because he was in Mexico making a film with Anthony Quinn (who won the best supporting actor Oscar the same night). And although he was staying in touch with Rocky and Maria, and frequently writing letters to "the girls," he had not

yet returned to live at home. That happened in the spring of 1954, not long after Hem and Mary's plane crashes but before Coop and Rocky went to Cuba to visit the Hemingways late that summer.[120]

Coop and Rocky had experienced a very difficult five years, but they saved their family, which grew stronger as the years passed. Writing of a photo taken of her parents six weeks before Coop's death, Maria said the "picture is about when two people have weathered life and its travails, its hurdles and pains, its separations and infidelities, and when love wins out over all human blindness."[121]

Around 1956, after hearing Rocky and Maria frequently joke after Sunday mass about the sermons preached by the funny but erudite priest, Father Harold Ford, Coop said he would like to hear one of those sermons someday. "Well, come along," said Rocky. Coop said he would.

As to whether Coop started attending because of pressure from Rocky, Maria later said that never would have happened: "Believe me, no one made my father do what he didn't want to do." Nor was Coop's interest in organized religion prompted by illness. "He was coming to this on his own, in his own time," added Maria, "bits and pieces of his own life that he wanted to put together in a new way."

After Coop and Father Ford met and got comfortable with each other, Rocky invited Father Ford to the house. He and Coop got along fine, but rather than discussing religion, they talked about their mutual love of guns, hunting, fishing and scuba diving. The friendship between priest and actor deepened, and they began conversing on matters of the spirit. The values Coop saw in Father Ford—and in Rocky and Maria, both devout Catholics—were quite compatible with his determination to "make films that showed the best a man could be."

Even with his wife and daughter, however, Coop was not one to talk much about spiritual matters or offer details on his visits with Father Ford. Maria felt he was probably looking for more stability than he had found personally, but he didn't say as much. Keeping his own timetable, Coop was baptized a Roman Catholic on April 9, 1959. Explaining his conversion, Coop said several months later:

> I'd spent all my waking hours…doing almost exactly what I, personally, wanted to do and what I wanted to do wasn't always the most polite thing either….This past winter I began to dwell a little more on what's been in my mind for a long time [and thought], "Coop, old boy, you owe somebody something for all your good fortune." I guess that's what

*started me thinking seriously about my religion. I'll never be anything like a saint....The only thing I can say for me is that I'm trying to be a little better. Maybe I'll succeed.*[122]

Through these years, Coop stayed in regular touch with Hem and knew that Hem's being awarded the Nobel Prize in literature in October 1954 had been more trial than triumph. He had been so overwhelmed by visitors, phone calls, telegrams and interview requests—as well as by the severe health problems caused by the plane accidents—that he likely told Coop what he had told Hotch: that his nerves were "shot to hell with pain" and that he couldn't write.[123] Both Hem and Coop must have longed for those days on Silver Creek.

Things hardly improved in 1955. In both June and September, Hem's writing schedule was interrupted and delayed because of matters related to the movie version of *The Old Man and the Sea*. In mid-November, Hem came down with hepatitis and nephritis and was bedfast for two months. Coop went to Cuba to check on him in February of '56, after which Hem was again tied up with the *Old Man* film. Little wonder that when Coop wrote to Hem in March, proposing they work together on a film of Stewart Edward White's great African adventure story *The Leopard Woman*, Hem said no thanks because he had vowed never to have anything to do with movies again.[124]

When Hem and Mary sailed to Europe in September of '56, they found the Coopers already there, and Coop was filming *Love in the Afternoon* with Audrey Hepburn. Coop joined Hem for drinks at the Ritz. A few days later, Pete Viertel arranged a luncheon that included Hem, Mel Ferrer, Audrey Hepburn and Rita Hayworth, but the pleasant meal was ruined when Hem was shockingly rude to an old man seeking autographs for his daughter. Viertel called it one of Hem's "mercurial changes of mood"— another sign of Hem's advancing mental illness because such an incident was unheard of in Idaho. Not surprisingly, Mary also felt that Hem was drinking far too much.[125]

Coop, Rocky and Maria also had their first of two meetings with Picasso that fall—a particular thrill for Coop, who had aspired to be an artist, and Maria, who had become one. (Picasso was already a friend of Hem's.) Over the course of the two visits, Coop brought perfect gifts for the great artist: a ten-gallon Stetson hat; a Colt .45 pistol, with Coop taking pains not to win a shooting contest between the two; and a spectacular eagle-feathered war bonnet of an American Indian chief.[126]

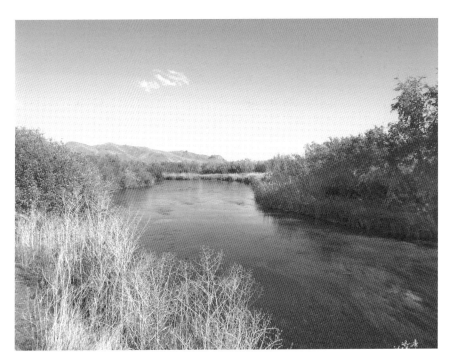

Silver Creek (*top*) and surrounding area (*bottom*), Hemingway and Cooper's favorite hunting site. *Photos by the author, 2016.*

In the spring of 1957, Hem slid "into an increasingly deep depression" as he struggled mightily to comply with doctors' orders to abstain from both sex and hard liquor. Much to his credit, by midsummer he was working on the memoir that would become *A Moveable Feast*. Also that summer, *Love in the Afternoon*, produced, directed and written by Billy Wilder, was released to favorable reviews, although more than one critic complained that the fifty-six-year-old Coop was too old to star with Audrey Hepburn, who was half his age. *Love* was the last Cooper film to rank in the annual top thirty moneymakers.

Hem worked hard on *A Moveable Feast* throughout much of 1958, and in September of that year, he and Mary came to Ketchum for the first time in almost ten years. Although Tillie had seen recent photos him, she was shocked to see how tired he looked and walked and acted. On the positive side, Hem had lost weight, was watching his diet and was drinking less. The Coopers showed up for a two-week visit in January of '59, and Hem and Coop finally hunted together again at Silver Creek, along the Snake River and in the desolate country near Craters of the Moon.

In February of '59, *The Hanging Tree*, starring Coop, Maria Schell and Karl Malden, was released. Jeffrey Meyers calls it "Coop's finest western after *High Noon*." It was a special pleasure for Coop because it was set in the Montana gold country during the 1860s and '70s and was written by the great Montana writer Dorothy M. Johnson, whom Coop befriended during shooting. When director Delmer Daves fell ill, Coop asked Malden to take over the direction. Malden complied despite his reluctance and did a fine job.[127]

Also in February, Clara Spiegel hosted a birthday dinner for Taylor "Beartracks" Williams, who was turning seventy-two. During Hem's long absence from Idaho, Taylor had made frequent trips to Cuba, and he and Hem had become close friends. The dinner and wine were perfect, and the local bakery had outdone itself with a cake showing "beartracks" winding through trees and a stream to a chocolate bear. Hem offered a heartfelt toast to his friend of twenty years. Twelve days later, Taylor was dead of a ruptured stomach wall. Hem, one of the pallbearers, was devastated.[128]

Hem and Mary left Ketchum for Cuba in March and left Cuba for New York and Spain in April, the same month that Coop and Charlton Heston began shooting *The Wreck of the Mary Deare* in England. Coop's failing health caused delays in the production, but Heston had high praise for his co-star and called working and becoming friends with Coop one of the most valuable experiences of his storied career.

While Coop was declining physically, Hem was plunging toward a mental and emotional collapse. In a sad attempt to recapture the heady 1920s days in Spain, Hem gathered with friends and followed the "mano a mano" battle for supremacy between two of Spain's greatest bullfighters. Trying to keep up with the matadors' incredibly demanding schedule, Hem was soon traveling hard and drinking hard and acting erratically. When Mary hosted a grand twenty-four-hour party to celebrate Hem's sixtieth birthday in July, Hem roundly belittled her virtually the entire time and even fell into the habit of mocking and criticizing Buck Lanham, who had been such a loyal friend for years.

The bullfighting competition did not end until late August, when one of the matadors was gored so badly that he could not continue.[129]

George and Pat Saviers, who had been present at the birthday disaster, understated the case considerably when they told Lloyd and Tillie that Hem was not taking care of himself, neglecting to take his medicine and drinking too much. The Arnolds were able to judge for themselves when Hem and Mary made it back to Ketchum in November. When the Arnolds first saw Hem, he was lost in a conversation with a guest—one of the bullfighters—and ignored them. When it came time for introductions, Hem stood staring absently into the fireplace, his fingers quivering near his lower lip. Tillie thought he looked worn out, alone and abandoned.

The Arnolds and others managed to get through the holidays without any ugly incidents and even have a good Christmas Day, with Hem seeming his old self at a gathering of friends, but everyone sensed there wouldn't be another good Christmas.[130]

Hem and Mary returned to Cuba in January 1960. Hem was now working on an article for *LIFE* about the bullfighting competition of 1959. He was writing despite high blood pressure and insomnia, but he was now writing obsessively, losing the discipline he had mastered over the years. *LIFE* had asked for a 10,000-word article, hefty for any magazine, but by April the count was at 63,000 words. The next month marked the first in what would turn out to be a series of "lasts" as he navigated *Pilar* out of the harbor for the last time. On July 21, what would be his last birthday went uncelebrated; four days later, he and Mary left Cuba for the last time. This was followed by a trip to Hem's beloved Spain, which he left for the last time on October 8. During this same period, Hem suspected—with no basis—that his friend Bill Davis was trying to kill him, and he wrote of fearing "a complete physical and nervous breakdown" and said he felt "dead in the head." By the end of May, his "article" was 120,000 words long.

As James M. Hutchisson wrote, "The medications that Hemingway took also ruined his physical and mental health." These included Reserpine, Wychol, Ritalin, Serpasil, Equanil and Seconal—the side effects and interactive effects of which were naturally not fully understood at the time. "Accidents, illness, hypochondria, depression, alcoholism, and finally paranoia settled around [Hemingway] like a fog that would not lift."[131]

Hem and Mary were back in Idaho the last week of October, his condition steadily worsening. Dr. George Saviers suggested a visit to the Menninger Clinic, but Hem refused to go to a facility known strictly as a psychiatric hospital. George countered with another proposal: he would take Hem to Minnesota's Mayo Clinic, where he could be treated for his high blood pressure, a legitimate concern. Hem agreed, and on November 30, Larry Johnson flew George and Hem to Rochester, where Hem was registered under George's name and admitted to psychiatric care. This was the same hospital complex where Lou Gehrig had been examined and tested in 1939. When Hem's last Christmas came, he was in the midst of a series of ten electroshock treatments.

Although he was mentally and emotionally strong, Coop's physical ailments during 1960 paralleled Hem's accelerating mental illness. In March, he called Hem with the news that he had been diagnosed with prostate cancer. Hem put up a cheerful front but privately said, "You can't beat the Big C. What a black-ass day this is."[132]

Coop had prostate surgery on April 14 and had to have another major surgery at the end of May to remove a malignant tumor from his large intestine. On May 2, the ever-hopeful Coop wrote a note thanking Hem and Mary for their telegram. "When I got it I got right out of bed and did three loops around the bottle. I was hooked up to a P. bottle with a tube coming out of 'you know what' and I looked like some sort of 'still' making a low grade grape juice."[133]

In August, Rocky wrote to Hem and Mary that Coop had been given a clean bill of health. He was about to film *The Naked Edge* in England, but Rocky hoped the Coopers and Hemingways could get together for a vacation afterward. That, of course, was already impossible because of Hem's condition. Nor would it be possible for Coop to develop and star in a film version of *Across the River and Into the Trees*, something he was still hoping to do as late as October 1960. (Who better to play the role of Richard Cantwell than Coop?)

Coop did not improve as expected, and he returned for more examinations and tests. His doctor waited until after Christmas to give Rocky the grim

news: his cancer had returned and was now terminal. Rocky and Maria decided not to tell Coop at that time, just as the real Eleanor Gehrig had decided not to inform her husband of his terminal illness.

In mid-January 1961, Coop and Rocky and Maria made their traditional skiing trip to Sun Valley. Rocky and Maria skied, and Coop spent a good deal of time alone in the wilds of central Idaho. George Saviers, a longtime friend of Coop's, came by and prescribed medication for Coop to help him be more comfortable. And although the newspapers had recently announced that Hem was being treated for high blood pressure at the Mayo Clinic, George confided in Coop, Rocky and Maria, telling them of Hem's fragile mental state and the therapy he was actually receiving in Minnesota.

When Lloyd Arnold returned from some business, he and Coop drove down to Silver Creek. "Coop wasn't especially interested in shooting anything; he wanted to prowl," wrote Lloyd. Rather than hunting, the two followed lonely dirt roads into "pockets of country" that hadn't been "poked into in years" to relive the good times of the past; to admire an eagle "flyin' high'n fancy," in Coop's words; and to catch a glimpse of jackrabbits bolting out of the high sage.

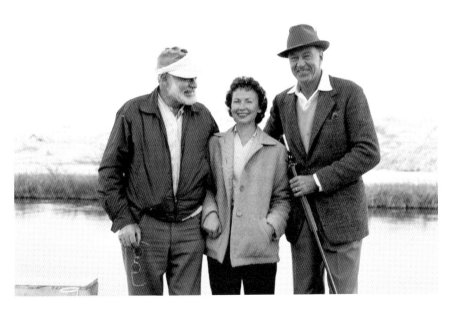

Ernest Hemingway and Gary Cooper with Bobbi Powell, Sliver Creek, 1959. *Photographer unknown, Papers of Ernest Hemingway, Photograph Collection, John F. Kennedy Presidential Library and Museum, Boston.*

One afternoon, Coop and Lloyd found themselves crossing the Snake River into the hamlet of Bliss, population ninety-one, "a stop for truckers with an eatery or two." Coop waved aside the menu offered by the waitress and "bet her that the cook might rustle up two orders of bacon and eggs and fried spuds, if she'd twist his arm."

The waitress nodded at Lloyd and said, "For this guy, sure, and for…well, Gary Cooper…now don't tell me you ain't him."

Lloyd said it was "just the sort of remark that Coop liked very much, from a friendly, being-herself, unflustered gal," and the dinner "went down very easy."

Word came that Larry Johnson was flying Hem back to Idaho—they would arrive the night before Coop, Rocky and Maria had to leave. Coop did not change his schedule to spend extra time with Hem, and Lloyd thought that a good thing because it would have embarrassed Hem to know he was being treated with kid gloves. "Nor do I believe," wrote Lloyd, "they would have discussed their problems more than a skimming over." He was right: that was Coop and Hem.[134]

Hemingway's grave lies in between the two trees in the foreground, with Mary's to the left and Gene Van Guilder's to the left of Mary's. *Photo by the author, 2016.*

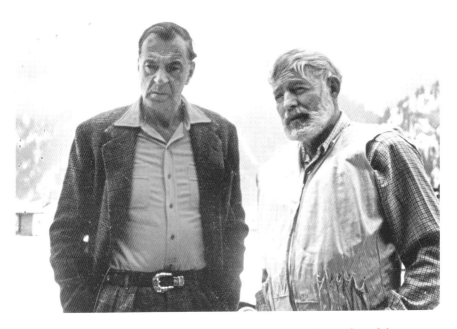

Gary Cooper and Ernest Hemingway in 1959—one of the last photos taken of the two friends. *Photographer unknown, Papers of Ernest Hemingway, Photograph Collection, John F. Kennedy Presidential Library and Museum, Boston.*

Hem arrived on Monday, January 23, and the Coopers drove from their hotel through the deep snow to the Hemingway home. Mary greeted them at the kitchen door, and then Hem came down the stairs, considerably thinner than when they had seen him last. George Saviers was already there, and the group of six friends sat down for drinks and conversation. It was a good evening. When it was time for the Coopers to leave, Hem, Coop, Rocky and Maria stood close together in the narrow hall. Coop told how he and his wife and daughter had gone to the cemetery the previous day and, after searching through the snow, had found the graves of both Beartracks Williams and Gene Van Guilder. Coop also told Hem how much they appreciated the inscription on Gene's grave—the quote from Hem's eulogy back in '39—and Rocky added that she wanted Hem to write similar lines for her and Coop. An uncomfortable silence followed and, wrote Maria, "then a mumbling from Ernest that said everything."

As they walked outside, Hem swung around and embraced Coop, and the two friends said what each of them feared would be their last goodbye.[135]

# "WE'RE VERY, VERY PROUD OF YOU, COOP"

On Monday, April 17, 1961, the thirty-third Academy Awards were held in the Santa Monica Civic Auditorium and broadcast over the ABC television network. Coop and Rocky and Maria were in their Bel-Air home, watching from Coop's room, and in Ketchum, Hem and Mary had invited Lloyd and Tillie over to watch with them.[136] During the program, master of ceremonies Bob Hope introduced William Wyler, Coop's friend for more than thirty years and his director for *The Westerner* and *Friendly Persuasion*. Wyler stepped to the podium and said:

> *The Academy Board of Governors has voted an award to one of our great stars. The citation reads—*
>
> *"To Gary Cooper, for his many memorable screen performances, as well as the international recognition as an individual, he has gained for himself and the motion picture industry—this is highly deserved and I feel privileged to present it—For a man who never has much to say, no one has ever said more to the credit of our industry than Gary Cooper. And more than that, to our country, because Gary Cooper represents the type of American who's loved in the four quarters of the earth. Contrary to popular belief, Coop is not a shy man—he's a humble man; he has humility, a great lost art, and not to be confused with weakness. And it comes through vividly on the screen and off. Many people, including Cooper, don't realize what a fine actor he really is. He has a rare and unique talent. He can do more with a look or a turn*

*of the head than most new vogues, waves and methods. His style is movie acting at its very best. The Academy gives this Oscar and all its love—in reverse order—to Mr. Gary Cooper."*

After a long applause from the audience, Wyler continued: "The award will be accepted by a close friend and a worthy stand-in—Mr. Jimmy Stewart."

Nineteen years had passed since Stewart, the previous year's best actor award winner for *The Philadelphia Story*, had presented the honor to Coop for *Sergeant York*, with Stewart—a newly commissioned second lieutenant in the U.S. Army—in uniform, and Coop sputtering out his acceptance speech. Sergeant Alvin York should have won the award, he said. "Shucks, I've been in the business sixteen years and sometimes dreamed I might get one of these. That's all I can say…funny, when I was dreaming I always made a better speech."

All smiles that night in 1942, Stewart, now fifty-two and his hair beginning to gray at the temples, entered to the music of *High Noon*'s theme, "Do Not Forsake Me, Oh My Darlin'," and was somber as he grasped the statuette. "I'm very honored to accept this award for Gary Cooper," he said. "I'm only sorry that he isn't here to accept it in person. But I know he's sitting beside his television set tonight…so Coop [holding the Oscar aloft] I'll get this to you [pause] right away [another pause] and Coop, I want you to know this—that with this goes all the warm friendship and the affection [longer pause] and [his voice now breaking] and the admiration and the deep—the deep respect of all of us [another pause as he stared at the statuette]. We're—we're very, very proud of you, Coop, all of us are tremendously proud." He turned and exited the stage as the audience applauded.[137]

In Idaho, Tillie noticed that Hem was profoundly affected by Jimmy Stewart's remarks, but Hem's serious mood apparently went unnoticed by Mary, who suggested they call Coop and congratulate him. Hem objected and offered several reasons why it was a bad idea, but Mary insisted and soon had Rocky on the phone. She then cheerfully talked to Coop, apparently not considering the implications of Stewart's demeanor while accepting the award. Then she said she would put Hem on the line and handed him the phone. Lloyd and Tillie both felt that Hem didn't want to talk to Coop and only took the phone because he couldn't refuse.

Almost a decade later, Lloyd recalled that Hem was clearly uneasy and uttered brief queries and replies, such as "How are you, Coop?"; "Well, Coop, I'm sick, too"; "Good old Coop"; and "Well, so long, Coop," with

long pauses in between. Tillie believed that Hem wasn't on the phone for longer than a minute.[138]

Rocky later reported Coop's side of the conversation between the two friends: when Hem said he wasn't feeling well, Coop replied, "I bet I'll beat you to the barn."[139]

Coop and Hem's first conversation—over the phone, with Coop elsewhere and Hem in Idaho, and with Coop doing most of the talking—was thus a precursor of their last conversation twenty-one and a half years later.

In an article written two years after Coop's death, Rocky offered more details on Jimmy Stewart's accepting the honorary Oscar. As Coop and Rocky and Maria were spending their last day in Sun Valley, Coop had put his arm around Rocky and asked, "Really, Rocky, is there anything the matter with me that I should know about?"

Rocky wrote that she was torn. She didn't want him to know but also didn't want to insult him. "I didn't say anything," she wrote, "but his words kept pounding through my head." Within a few weeks, Rocky and Maria decided it was time to tell him and felt it would be best for his doctor, Rex Kennemar, to be present when the bad news was revealed. The meeting at Dr. Kennemar's office was held on February 27, 1961, with the doctor later calling it the most dramatic moment of his life. "Composed and unflinching," wrote Rocky, "Gary asked how long he had to live." Dr. Kennemar said he might have a year if the cancer slowed down (although he had privately told Rocky and Maria two months earlier that Coop had six months at most). "We'll pray for a miracle," Coop later said, "but if not, and that's God's will, that's all right too."

But rather than regressing, the cancer rapidly advanced. Coop didn't want anyone to know, and he and Rocky and Maria kept up appearances and did their best to make the most of the time remaining. In March, Coop flew to New York and recorded the narration for an NBC documentary called *The Real West*, his last project, a worthy venture tailor-made for an unassuming actor who loved his native West and understood its origins.

Months earlier, Jerry Wald had told Coop about the documentary, which would be produced and directed by a young talent named Donald Hyatt. Coop contacted Hyatt himself and asked if they could talk sometime. Hyatt said absolutely and was thrilled when Coop showed up at the NBC headquarters to see him. Coop, he later wrote, wanted very much to have western history "portrayed accurately and truthfully portrayed on television, and he was completely committed to being part of the effort to do it."

The fields near Dietrich offered excellent pheasant hunting, and Hemingway liked the connection (although in name only) to Marlene Dietrich. *Photos by the author, 2016.*

Coop would appear on camera at the beginning and end of the sixty-minute program and a few times in between and narrate the compelling photographic vignettes telling of westward trekkers, gold seekers, school marms, cowhands, lawmen and outlaws and the Indian nations forced from the lands of their inheritance. Coop's on-camera parts were filmed in December, when he was already in constant pain, but he never complained and never acted like a star. "I want you to let me know what you like and dislike and tell me what to do," he said to Hyatt. His work in March—when he did know his illness was fatal—was that much more difficult, but Coop was once again a true professional.[140]

Father Ford was a frequent visitor to the Cooper home, and one night, Rocky heard Coop tell the priest that he now knew what it was like to want to die and that he wasn't afraid. Rocky had a hard time controlling her emotions at such times, but Coop said, "Please Rocky, no blubbering" whenever she cried.

"Panicky," wrote Rocky, "I called our close friend Jimmy Stewart and, in tears, blurted out everything."[141] Given his temperament and his admiration for and friendship with Coop, asking Stewart to somehow accept the Oscar on Coop's behalf without getting emotional would have been asking the impossible. As for Coop, he was deeply moved by Stewart's tribute and not bothered that his fatal illness had essentially been disclosed on national TV. As promised, Stewart—accompanied by his wife, Gloria—delivered the Oscar later that night. Gloria and Stewart had met in 1948 when matchmakers Rocky and Coop sent them separate invitations to a dinner at the Cooper home. The Stewarts visited again a week or two later, when the two great stars of Frank Capra's heartwarming productions had a chance to talk for the last time.[142]

Three days after the awards ceremony, an Associated Press story appeared in newspapers throughout the country. "Gary Cooper Is Ill with Cancer" ran the headline in the Helena, Montana *Independent Record*. "Sources close to Gary Cooper say the veteran film star is gravely ill with cancer—and knows it," read the first line. As the article pointed out, speculation about Cooper's condition had reached a virtual frenzy after Jimmy Stewart "nearly broke into tears as he spoke words of tribute." Publicist Warren Cowan had issued the following statement on Wednesday, April 19: "Because the Cooper family has been inundated by inquiries about his health since the Jimmy Stewart presentation, I am asked by the family to say that he is gravely ill." Cowan did not disclose any specifics, but other sources had confirmed that Coop was suffering from cancer.

In an article published a week after Cowan's announcement, *LIFE* magazine reported that a few days after Coop's health crisis was made public, "a Hollywood correspondent wired his New York office. 'I have never known this town to be so depressed.'"[143]

Letters and telegrams poured in. Coop found the messages quite touching, but as Maria wrote, "one telegram in particular moved him greatly: 'Sorry to hear of your illness. You have my prayers and sympathy for your speedy recovery. Your friend and comrade, Sergeant Alvin C. York.'"[144]

In Coop's final weeks, visitors besides Jimmy and Gloria Stewart included Sam and Frances Goldwyn; Fred MacMurray and his wife, June Haver; Audrey Hepburn and Mel Ferrer; Robert Stack; Billy Wilder; and Jack Benny.[145] Aaron Hotchner also reported seeing Coop about ten days before he died. Rocky took him to the room and then left them alone. "He was a wasted figure, lying immobile in his darkened room," wrote Hotch. "His hair was grey-streaked where the dye had left it."

Coop, pausing between words because of the pain, said that Hem had called him two weeks earlier. Hem had said he was sick too, but, said Coop, "I bet him that I will beat him out to the barn."[146] After smiling, closing his eyes and seeming to drift off, Coop said he had heard on the radio that Hem was back at Mayo's. He asked Hotch if that were true. Yes, answered Hotch. Coop, of course, knew perfectly well what kind of things were likely happening to Hem at Mayo's.

"Poor Papa," said Coop, who was hit by a wave of pain and unable to talk. When the pain subsided, he picked up a crucifix from the bedside table and asked Hotch to give Hem a message, saying Hotch must not forget because Coop wouldn't have the chance to talk to him again. "Tell him…that time I wondered if I made the right decision"—touching his cheek with the crucifix and undoubtedly referring to his conversion to Catholicism—"tell him it was the best thing I ever did."

"Don't worry, Coops," said Hotch. "I'll tell him."[147]

The movie producer Bill Goetz, called a "witty and loveable man" by Coop's biographer, and his wife, Edie, had been good friends of the Coopers for years; they were also among the friends who offered love and solace. Edie called Danny Kaye and asked him to come to the Cooper house and to "dress crazy." Kaye came right away, "improvised a comic routine, and Cooper *did* laugh."[148]

Rocky wrote that Coop's "inner strength, his understanding of himself, his unshakable courage and religious faith grew stronger" as the end drew near. "No one faced such agonizing destruction more bravely." She and Coop

The hills of south-central Idaho that reminded Hemingway so much of Spain. *Photo by the author, 2016.*

had discussed possible efforts to prolong Coop's life, but they agreed that such efforts offered no hope when they simply prolonged suffering. Instead, wrote Rocky, "I found myself praying for God's will and for the alleviation of Gary's excruciating suffering."[149]

At the end, two nurses traded shifts, caring for Coop twenty-four hours a day, with daily supervision by Dr. Kennemar. Father Ford had been transferred to another parish, but Monsignor Daniel Sullivan made regular visits and administered the last rites the day before Coop's death. Rocky, Maria and Coop's mother, Alice, kept a constant vigil at their husband, father and son's bedside.

On Sunday, May 14, twenty-seven days after the Academy Awards and one week after Coop's sixtieth birthday, the *San Bernardino Sun-Telegram* ran a front-page headline that read, "Grim Fight with Death Ends for Gary Cooper." The article, subtitled "Movie Colony in Mourning as Actor Dies," continued:

> *Gary Cooper died yesterday of cancer after a deathbed fight that rivaled in courage the heroic roles he played in 35 years in motion pictures.*

Cooper, *far left*, and Hemingway, *second from right*, hunting with friends at Silver Creek, circa 1959. *Photographer unknown, Papers of Ernest Hemingway, Photograph Collection, John F. Kennedy Presidential Library and Museum, Boston.*

> *The tall, taciturn screen hero was 60 a few days ago.*
> *He had lingered at death's door for days and was heavily drugged to ease*
> *the pain that wracked his once-powerful, 6-foot-3-inch body. He died at*
> *12:27 p.m. (PDT)*[150]

The article was accompanied by a photo of Rocky, Coop and Maria taken the previous autumn, upon their arrival in New York from London. The photo shows a smiling Coop, though seriously ailing by this time, conspicuously honoring Hem by holding a copy of the September 5, 1960 issue of *LIFE* magazine that featured a grinning Ernest Hemingway on the cover. The caption read, "Hemingway: The Dangerous Summer, Part 1."

Hem, however, likely never saw the Associated Press story or the photo that included his image along with those of Coop, Rocky and Maria. While that bit of information in itself would hardly be startling, it hints at something much more significant: despite widespread assumptions about Hem's reaction to Coop's death, no one left a record of when and how he got the sad news or how he responded.

CHAPTER 8

# "A COUPLE OF DRAWERS
# BANGING SHUT"

In March, as Coop was completing the narration for *The Real West* despite his deteriorating condition, Hem's depression had not only returned but was also worse. He was also acting irrationally. On March 6, he warned Hotch that mail and phone calls were likely being monitored by the Federal Bureau of Investigation. Two weeks later, he fixated on whether Mary had paid Social Security tax for their maid. He demanded to see her checkbook, saying that the FBI would certainly examine it. Mary refused, and a heated argument ensued, further fracturing Hem's delicate state of mind. On April 15, Hem's deepening depression and paranoia were compounded by reports from Cuba of the Bay of Pigs fiasco, convincing Hem that two key manuscripts (later to become *Islands in the Stream* and *True at First Light*) were lost and that he had seen the Finca, his paintings, his books and the *Pilar* for the last time.[151]

Two days later, of course, Hem and Mary and Lloyd and Tillie saw Jimmy Stewart's poignant disclosure, and Hem talked to Coop, at least half comprehending that Coop's death was imminent. The next day, April 18, Hem wrote—but didn't mail—a letter to Charles Scribner describing his worries over the Paris memoir and his creative impotence, essentially acknowledging that any respite from depression resulting from the Mayo Clinic treatments had now vanished. On April 20, Tillie saw Hem walking as she was driving home for lunch. She knew he wanted to talk, but he was hesitant and started rambling about an "incurable disease." She could distinctly remember a conversation in 1939 when Hem had used that term

in discussing when suicide might be justified. She asked if he were referring to what he had said in '39. "Yes, daughter, I am," he said. "There is no other way out for me. I am not going back to Rochester where they will lock me up. I can't live like that."

"Papa," she said, "I don't blame you." It would be their last conversation, one that Tillie never told Lloyd or Mary about.[152]

Hem acted quickly on his intention. On Friday morning, April 21, Mary went downstairs for breakfast and found Hem "in the front vestibule of the house with his shotgun, two shells and a note he had written me." Rather than confronting him, Mary talked about the possibility of going to Mexico. "Gregorio might be able to get *Pilar* over there," she said. She knew George Saviers was due for his regular blood pressure check and hoped to delay Hem until the doctor arrived. She sat on the sofa and talked to Hem "about courage and his bravery in the war and at sea and in Africa, reminding him that he wanted to return to Africa, reminding him how many people loved him and needed his strength, his wisdom, his counsel." Finally, fifty minutes later than usual, with Hem still holding the shotgun, George came in through the back door, understood what was happening and said, as nonchalantly as possible, "Hang on, Papa, I want to talk to you." The tension eased, George called Dr. John Moritz, who quickly joined them. The two physicians persuaded Hem to go with them to the hospital, where he was sedated and slept most of the day.[153]

Mary and George planned to return Hem to Rochester as soon as possible, but bad weather prevented any flights out of Hailey. On Monday, April 24, Hem convinced George he needed to return home to pick up some things. Don Anderson, a hunting companion of Hem's, and nurse Joanie Higgons went with Hem, but as soon as Don stopped the car, Hem galloped into the house, grabbed a shotgun and had a shell in the breach before "big, husky" Don could subdue him, open the breach and allow Joanie to get the shell. Back at the hospital, Hem was sedated again.

On Tuesday, Larry Johnson flew Don, George and Hem back to Rochester, with Hem going against his will. Mary was too exhausted and shaken to accompany them. She wrote to Hem's sister Ursula that Hem was "immoveably convinced that he cannot be healed."[154] At a fuel stop in Rapid City, South Dakota, with the Piper PA-24 Comanche plane needing minor repairs, Hem got out, supposedly to stretch his legs. Carlos Baker described what happened next: "Don stayed doggedly at his heels while he [looked] for a gun, and pawed through drawers and tool chests in the sheds, murmuring that they often kept guns in such places.… When the Comanche was ready to

go, he saw another plane taxiing down the ramp and walked straight toward its whirling propellers. He and Don were no more than thirty feet away when the pilot cut the engines and Ernest lost interest."[155]

The next day, both the AP and UPI wire services announced that "Novelist Ernest Hemingway was back under Mayo Clinic care…for further treatment for the hypertension condition which hospitalized him earlier this year." Airport attendants in Minnesota said the writer looked tired. "Rest and quiet are absolutely essential to his treatment," said a clinic spokesman, adding that no additional information would be forthcoming.[156]

Hem's "hypertension" was treated with another round of electroshock therapy, and despite what appeared in the newspapers, friends likely suspected that high blood pressure was not the issue. On Saturday, April 29, a telegram came from Rocky and Coop, who, of course, knew the true nature of Hem's ailments: WHATS THERE TO SAY EXCEPT THAT YOU HAVE OUR LOVE?[157] This was the last communication between Coop and Hem.

About this same time, in Idaho, Mary received a phone call from Rocky, who thanked Mary for her letter to Coop (sent after his condition became public). Rocky sent her best to Hem and said Coop was having a hard time but was "gallant as springtime."

Hem, who wouldn't see Mary until the last week in May, carried on a correspondence with her that betrayed all-too-familiar symptoms—shaky handwriting that didn't look familiar, frequent repetitions, obsessive fretting over finances and repeated demands to see the balances of various bank accounts. On May 5, Hem wrote that he was lonely, that a session in the white room had left him unable to write and that he nevertheless would continue to receive a treatment every other day. He was kept under close supervision in a locked, barred wing of the hospital, and Mary said his room contained "a few books, a few magazines, a few letters. No typewriter, no telephone, no pictures, no flowers." Such was the spiritless, wearisome routine when Saturday, May 13, came and went.[158]

Coop died less than half an hour after "high noon" that day, but neither Mary nor Hotch nor any other friends or relatives were on the scene to break the news to Hem. There is no indication that anyone else told him. On May 25, Mary arrived at the request of a Mayo physician for what would now be called a "conjugal visit" with Hem.[159] In her memoir, Mary makes no mention of discussing Coop's death with Hem at that time—or anytime thereafter. Likewise, Hotch spoke on the phone with Hem in May and visited him in June (finding him highly volatile) but left no record of ever talking to him about Coop's death.

In addition, although Hem had access to newspapers at the Mayo, it is simply unknown whether he happened on an article announcing the loss of one of his truest friends.

In a June 10 letter to Charles Scribner, Hem sounded coherent and upbeat, even discussing how a recently published guide to fishing in Yellowstone Park was significant because the 1959 Hebgen Lake earthquake had radically changed the fishing scene in Yellowstone. He said nothing about Coop.

The only documented evidence of anyone mentioning Coop's passing to Hem comes from Hadley's biographer, Gioia Diliberto, who wrote that when Hadley read in a newspaper that Hem was too ill to attend Coop's funeral, she wrote to Hem (on May 20) and said she hoped that something other than illness had prevented him from going. She also enclosed a self-addressed stamped envelope asking Hem to send reassuring words about his health, but as far as is known, he never replied.[160]

At the end of May, Mary flew back to New York and consulted with psychiatrist James Cottell, who had previously discussed the case with Hotch. Mary asked him about transferring Hem to another facility. Not having examined Hem, Dr. Cottell could not make specific recommendations, but he indicated that with Dr. Rome's authorization, moving Hem to a psychiatric hospital in Connecticut might have value. Mary flew to Connecticut and toured the complex, "noting people reading peaceably in a library and others playing softball outdoors, and concluded that our only problem was that Ernest would never consent to go there."[161] Although Mary wrote to Dr. Rome about a possible transfer and hoped he would convince Hem to go, nothing developed.

Hotch flew to Minnesota in June, drove Hem to a wooded area and tried without success to lift his spirits. "What does a man care about?" Hem asked him. "Staying healthy. Working good. Eating and drinking with his friends. Enjoying himself in bed. I haven't any of them."

Hotch protested but gave up when Hem accused him of obtaining information to "sell out" to the feds. "Late in the day I drove back to Minneapolis," wrote Hotch. "I never saw him again."[162]

Later in June, Mary returned to the Mayo for what she thought was just another visit, but not long after her arrival, she got a call at her hotel from Dr. Rome, asking her to meet him at his office the next morning. When she arrived, she was "dumbfounded to see Ernest there, grinning like a Cheshire cat." The doctor announced that Hem was ready to go home. Mary did not believe that for a minute but felt it useless to protest with Hem in the room and fully expecting to return to Idaho.

Mary called George Brown in New York and asked if he could fly out and drive them to Idaho. He agreed, dropping his personal business, and arrived the next day. Mary rented a hardtop Buick, and they departed Rochester early on the morning of Monday, June 26, making their way across the corn fields of southern Minnesota, into South Dakota and past Sioux Falls to Mitchell. Mary kept close track of mileage and kept detailed notes of the journey, the kind of thing Hem would have done in happier times. They made about 340 miles that first day.

Tuesday morning, they rose early and drove west, and no one would have appreciated the particular route they were about to travel more than Coop. *The Real West*, which had been broadcast late in March, opens with solemn music accompanied by stark black-and-white images—a ghost town, a pioneer cemetery overgrown with grass and brush, a horned ox skull lying beneath a barbed wire fence, a solitary wagon wheel and close-ups of abandoned buildings. As the credits roll, Gary Cooper is identified not as the narrator but the storyteller. The camera follows Coop, looking perfectly at home in western garb and hat and holding a sturdy branch just right for waving, pointing or tapping, as he walks onto a "ghost town" set and says it could be Elkhorn, Montana, just a few miles from where he was born and raised, or any of a number of other once-bustling settlements that died. Next, defining "the West," he draws a line in the dirt with the switch and says, "If you drop a line down the hundredth meridian like this, everything on this side of it, with an annual rainfall of less than twenty inches—that was the West."[163]

About 110 miles from Mitchell, George, Mary and Hem crossed the 100th meridian, and the lack of rainfall was soon more than evident when they saw the parched buttes of the badlands. At a roadside table near Spearfish, Hem said he wanted to stay right where they were, even though state troopers would probably arrest them for having wine in the trunk. Mary threw out the wine to ease his mind, and the three of them pushed on another 56 miles to Moorcroft, Wyoming, where they ate at a small café that served the worst coffee Mary had tasted since World War II and got a nondescript motel room, logging another 420 miles.

They had not driven far on June 28 when they reached Gillette, Wyoming. At this point, they could reach Ketchum from the east by way of Idaho Falls or from the north by way of Salmon, Idaho. The former, the shorter route, would take them across Wyoming and through Yellowstone Park, Hem's favorite route. The latter route was at least two hundred miles longer and would take them across Montana, a path never taken by Hem when returning

to Idaho from the east. The threesome went north, which meant Hem would see all three of the western states he loved so much—Wyoming, Montana and Idaho. But Mary never said whether Hem made any comments at all about their route.

Next came Lodge Grass, Montana, and its six-hundred-odd inhabitants, where Mary, George and Hem filled up with gas and ordered a late breakfast. Not long after that, they paused but did not stop at the site of Custer's Last Stand. It is hard to imagine a younger Hem not stopping to soak in such rich history—as Coop had done with an Indian elder in 1957—but George drove on, clocking 409 miles before they stopped at the Island Resort Motel in Livingston. From their open window, wrote Mary, they could hear the "faint song" of the Yellowstone River, the same river Hem had followed that fine September day in 1939 when he was on his way to that memorable reunion with Jack, Hadley and Paul.

On Thursday, June 29, the trio of travelers got an early start and went west to Three Forks and then north. At Canyon Ferry Lake, they saw six antelope—a mature buck, a young one and four does. Then they drove west to an area where gold had been discovered on July 14, 1864, and a town called Last Chance Gulch had been founded. The name was soon changed to Helena, and it became the territorial capital in 1875. Helena was the hometown of one Frank James Cooper, born on May 7, 1901. His father, Charles H. Cooper, a future Montana Supreme Court justice, had emigrated from England and arrived in Helena in 1889 at age twenty-four. From Helena they crossed west to Missoula, Robert Jordan's last American home, and then, wrote Mary, "turned south onto our familiar, twisty U.S. 93."[164]

Picking up the Lewis and Clark trail for the umpteenth time, Mary, George and Hem went south, through Lolo, Stevensville and Darby. Near Sula they passed through a picturesque valley called Ross' Hole, a significant site for Coop. As a young aspiring artist, he had loved the work of the great Montana artist Charles Russell, and his favorite piece was Russell's largest painting, measuring twenty-five by twelve feet and entitled *Lewis and Clark Meeting Indians at Ross' Hole*, produced when Coop was eleven years old. Of all of Russell's depictions of the expedition, none was more magnificent than this grand panorama that graces an entire wall of the chamber of the Montana House of Representatives and was visited by Coop on his last trip to his home state.

The painting depicts the first meeting of the Salish Indians with Lewis and Clark's party, which had just made an arduous passage over the

*Lewis and Clark Meeting Indians at Ross' Hole*, by Charles Russell, a friend of Cooper's father. *Montana Historical Society Research Center, Archives.*

Bitterroot Mountains. Lewis and Clark are in the background, as their Shoshone interpreter communicates in sign language with a Salish chief. Also in the background are rolling foothills, shrouded mist, the snow-capped Bitterroots, the spectacular Montana "big sky" and the teepees of the Salish village. But the foreground is dominated by a half-dozen Salish warriors armed with lances and swinging their galloping horses to a halt amid a pack of growling dogs.

William Clark wrote that he and Lewis met a part of the Salish nation "of 33 Lodges about 80 men 400 Total and at least 500 horses, those people recved us friendly, threw white robes over our Sholders & Smoked in the pipes of peace."[165]

Hem and Mary were now in that very spot; what a pleasure it would have been in younger days to later sit near a Sun Valley Lodge fireplace with Coop and Rocky and sip wine while reporting on the trip and hearing Coop talk about Russell's unforgettable work of art. But Mary said nothing of the valley and nothing of this section of Highway 93 following the 1,200-mile trail of tears that Nez Perce chief Joseph and his people had taken as they attempted to flee to Canada.

At the conclusion of *The Real West*, Coop acknowledges that there was glory in what the westerners had done. "But," he adds, his voice rich with sympathy, "there was tragedy too—because someone was there first." The crime of the Indians was "being in the way." Coop hardly had to feign such sentiments because, as Maria later wrote, "his passion for the Indians was deep. His sense of anger at the injustices done to them deeper still." Next

Coop recites the names of a dozen and a half Indian nations who were "there first." The longest war in America, he adds, the twenty-eight-year war, was "fought between two American armies on their own American soil." Again, he recites a simple list—one that includes both battlefields and massacre sites, such as Sand Creek, Washita, Salt River Canyon and Wounded Knee. Also Big Hole, where Chief Joseph's band had been attacked in August 1877. Had George, Mary and Hem turned left at Montana Highway 43 rather than continuing south, they could have reached the site in thirty minutes.

In his final performance, less than two months before his passing, a sick but determined Coop had portrayed not a fictitious person but, as with the address so meaningful to those beaming young men in the South Pacific seventeen years earlier, a real man and his own words, a performance that would serve as a fitting capstone to his long and fruitful career. In 1943, he had recited the words of Lou Gehrig—now the words of Chief Joseph, simply called "a gallant Indian warrior" in Coop's narration: "I am tired of fighting. Our Chiefs are killed. The old men are all dead; the little children are freezing to death. My people have run away to the hills and have no food. No one knows where they are. I want to have time to look for my children. Maybe I shall find them among the dead. Hear me, my Chiefs! I am tired; my heart is sad and sick. From where the sun now stands I will fight no more. Forever."[166]

At 5:45 p.m., George and Mary and Hem reached the Herndon New Courts motel in Salmon, Idaho, making slightly more than 400 miles for the third straight day. Home was now less than 200 miles away, and on Friday, June 30, they enjoyed a picnic along the Salmon River and then made their way through Challis and Stanley, on the edge of the well-named Sawtooth Mountains. Winding southeast, they passed 8,990-foot Galena Summit, also seen by Coop, Rocky and Maria on one of their last days in Idaho five months earlier. By midafternoon, the Ketchum house came into view—1,786 miles from Rochester.[167]

Hem seemed to be in good spirits on Saturday, July 1. The day was clear and pleasant, and Hem asked George to walk with him up into the hills north of the house. They later stopped to see George Saviers at the hospital. Shortly after that, Tillie was parked at the Atkinson store when she saw Hem "making a beeline into the store," with George Brown trying to keep up with him. Tillie, who hadn't seen Hem since that day in April when he hinted at suicide, was shocked at how thin and pale he looked, "like a dead man walking." After a moment, concluding that she could not bear to talk to Hem under these conditions, she drove for home. She never saw him again.[168]

The Christiania Restaurant in Ketchum, where Ernest and Mary ate their last meal together on the evening of July 1, 1961. *Photo by the author, 2016.*

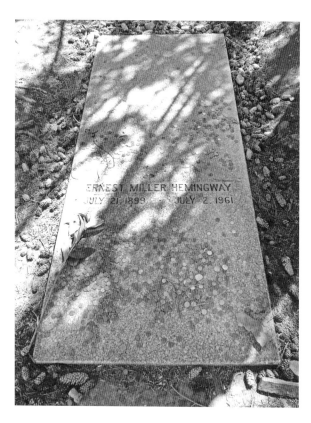

Ernest Hemingway's grave, Ketchum, Idaho. *Photo by the author, 2016.*

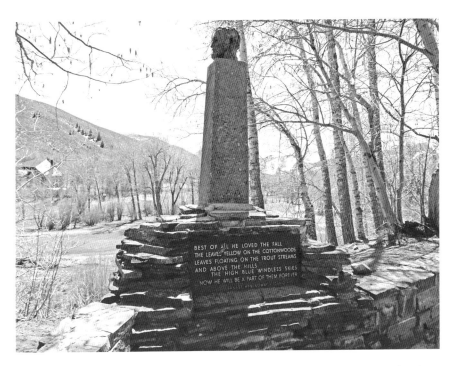

Two views of the Hemingway Memorial, which includes a quote from Hemingway's eulogy for Gene Van Guilder, Sun Valley, Idaho. *Photos by the author, 2016.*

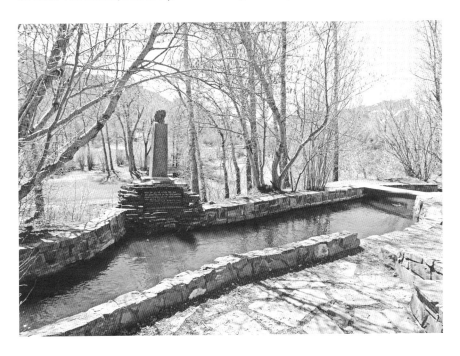

That night, Mary and George took Hem to dinner at the Christiania Restaurant. When Hem saw two men eating a few tables away, he asked the waitress who they were. Probably two salesmen from Twin Falls, she answered. No, said Hem, not on a Saturday night—they would be home in Twin. They weren't salesmen but FBI agents. Mary tried to distract him with conversation and a glass of wine, but his paranoia persisted. Luckily, they got through the meal without public incident.

At home, with George sleeping in the nearby guest house, Mary and Hem prepared for bed. As she was undressing in the living room, Mary sang a line from an old Italian folk song, and Hem, in his bedroom next door, joined her in the next phrase. From her own room, Mary called out goodnight and told him to sleep well. "Good night, my kitten," he responded, and he sounded happy.[169]

The next morning, a Sunday, when the July sun had finally topped the Sawtooths and came streaming in through the windows, Mary woke to a loud noise that sounded like two drawers banging shut, but it was actually the booms of two shotgun blasts, an echo of the dual reverberations that had marked the start of Hem's time in Idaho—and his comradeship with Coop—in 1939. The blasts twenty-two years earlier had also been heard on a Sabbath, and in many ways, Hem was as much the victim of an accident as his good friend Gene Van Guilder.

## CHAPTER 9

# "THE HILLS REMAIN"

On July 2 and 3, 1961, newspapers worldwide ran front-page stories about the death of the most famous writer of the twentieth century. John Bittner, a journalism professor who thoroughly researched that news coverage, described the situation in Paris, the writer's favorite city:

> On the unusually cool, first Monday morning in July 1961, business people and tourists walking the Champs-Elysees stopped outside the offices of Le Figaro to read from the long display case where the edition de 5 heur was posted.... With Algeria and de Gaulle crowding the French news hole, it was significant that a prominent photo on the front page of Le Figaro that morning showed a bearded man with his head slightly bowed, wearing a checked tweed cap. This photograph of Ernest Hemingway...was positioned near the top of the page just under the masthead. The headline read, "Vie hors serie, fin dramatique..."—"incomparable life, dramatic ending...."[170]

The July 2 issue of the *New York Times* also included a photo of Hemingway on the front page, with quite a different headline: "Hemingway Dead of Shotgun Wound; Wife Says He Was Cleaning Weapon." Although leading with Mary's prepared statement that "Mr. Hemingway accidentally killed himself while cleaning a gun this morning at 7:30 A.M.," the article hardly minced words about the possibility of the "accident" actually being a suicide.[171]

The *San Bernardino Daily Sun* ran an article and a captioned photo of Hemingway, both on the front page. The headline, "Famed Author Hemingway Kills Self with Shotgun," was clarified by an opening paragraph quoting Mary that the death had been accidental. After citing statements from Blaine County officials and summarizing Hemingway's recent stays at the Mayo Clinic, the *Sun* piece discussed a relevant point ignored by the *Times*: "There were reports in this area that Hemingway had been in good spirits…but that he had been saddened by the recent death of his good friend, actor Gary Cooper."[172]

Nor was Hem's passing ignored by Pocatello's *Idaho State Journal*, with the banner headline proclaiming, "Hemingway Dies of Shotgun Blast," complemented by the subtitle, "Violent Death in Idaho Home Shocks World." Some of Papa's friends, stated the article, said that Hemingway seemed distressed "and traced it to the recent cancer death of actor Gary Cooper, his close friend and hunting companion." When Hemingway told Cooper he wasn't feeling well, Cooper had replied, "I'll bet I beat you to the

The graveside service for Ernest Hemingway, July 6, 1961, Ketchum, Idaho. *Community Library Regional History Department, Ketchum, Idaho, F06495.*

Ernest Hemingway Elementary School, Ketchum, Idaho. *Photo by the author, 2016.*

barn." Upon hearing of Hemingway's death, Rocky Cooper said, "They're both in the barn now."

Four additional stories ran on the front page: "Kennedy Lauds Hemingway," "Pocatello Priest Remembers 'Down-to-Earth' Hemingway," "Author's Son Wed to Ex-Pocatello Girl" and "Acting Governor Expresses Regrets." The second page of the paper followed up with two other articles: "Ketchum Recalls Hemingway as Reserved, but Friendly" and "Ernie Always Talked About Guns, Hunting."

Hem was buried in the Ketchum Cemetery on Thursday, July 6. The pallbearers were Dr. George Saviers, Forrest McMullan, Don Anderson, Lloyd Arnold, George Brown, Chuck Atkinson and Bud Purdy, with Toby Bruce as an honorary pallbearer.

On June 15, 1961, in the last letter he is known to have written, Hem penned a short but perfectly coherent note to Fritz Saviers, George's nine-year-old son, who was hospitalized with a viral heart disease. Hem was sorry to hear that Fritz was "laid up" and hoped he would be feeling better soon. The weather in Rochester had been muggy and hot, but it had turned cooler recently and the nights were good for sleeping. Next came a description of the beautiful country along the Mississippi River and the ducks and pheasants that could be seen in the fall. Hem hoped he and Fritz would see each other soon and joke about their hospital stays. "Best always to you, old timer from your good friend who misses you very much."[173]

On April 11, 1966, Maria Cooper, who studied art at the Chounaird Art School in Los Angeles, married Byron Janis, a world-renowned concert pianist. Byron had a son, Stefan, from a previous marriage. In 2010, a fascinating book was published—*Chopin and Beyond: My Extraordinary Life in Music and the Paranormal*, by Byron Janis, with Maria Cooper Janis. In 2013, Byron wrote the powerful score of John Mulholland's fine documentary *Cooper and Hemingway: The True Gen*. Maria and Byron have been longtime supporters of the arts in New York City. They are also both involved with the National Arthritis Foundation (with Byron as the national spokesperson), and Maria is active in such causes as Pro Musicis, an organization that helps further the careers of young musicians; the Neuropathy Foundation; and the Americana Society for Psychical Research. Maria has had a successful career as an artist, with exhibitions in the United States, Europe and Asia.

Coop's mother, Alice Louise Brazier Cooper, died of an extended illness on October 6, 1967, at the California Convalescent Hospital in Palm Springs at age ninety-four, surviving her husband, Charles, by almost twenty-three years. Born in England, she met Charles (who was also born in England) while visiting her brother in Helena. Overbearing at times, Alice was instrumental in Coop's break-ups with both Lupe Velez and Patricia Neal. Alice also objected to Maria's being raised Roman Catholic—as well as to Coop's eventual conversion—but the easygoing Coop didn't seem bothered and always treated his mother well. Maria remembered her Grandmother Alice as one who loved restaurants and cameras and everything else that went with being Gary Cooper's mother but also as a strong-willed woman who once held off a gang of escaped Montana prisoners with a shotgun. After Alice's death, Rocky had Coop's remains exhumed and reinterred at Sacred Heart Cemetery in Southampton, New York, where Rocky had resided for several years.[174]

On March 26, 1970, the *Idaho State Journal* announced that "prominent Idaho author, photographer and sportsman, Lloyd R. Arnold, 63," had died of a lingering illness five days earlier in Phoenix, Arizona. Lloyd had been the chief photographer for Union Pacific at Sun Valley from 1939 to 1962 and had won several awards for his photography. He had also served as mayor of Ketchum. In 1968, he had simultaneously published *High on the Wild with Hemingway* and *Hemingway: High on the Wild*, long and short pictorial narratives, respectively, about his good friend Ernest Hemingway. He was survived by a brother and his widow, Tillie.

On September 21, 1974, Walter Brennan died in an Oxnard, California hospital of emphysema at age eighty. He had been Coop's co-star in six films:

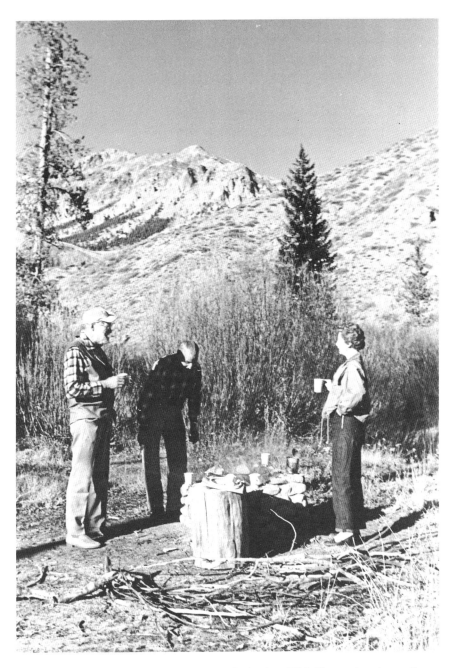

Hemingway and Lloyd and Tillie Arnold at a picnic, circa 1959. *Photographer unknown, Papers of Ernest Hemingway, Photograph Collection, John F. Kennedy Presidential Library and Museum, Boston.*

The headstone for Lloyd and Tillie Arnold, Ketchum, Idaho. *Photo by the author, 2016.*

*Land of Liberty* (1939), *The Westerner* (1940), *Meet John Doe* (1941), *Sergeant York* (1941), *The Pride of the Yankees* (1942) and *Task Force* (1949). Jimmy Stewart, who appeared with Brennan in *The Far Country* and *How The West Was Won*, called Brennan "the ideal motion picture character actor." According to a UPI news story published two days after his death, "Brennan was watching *The Westerner* on a local television station when he died....His wife, Ruth, his eldest son, Michael, and his granddaughter, Susan Lademan, were with him at the time."[175]

Elizabeth Hadley Richardson Hemingway Mowrer died on January 23, 1979, in Lakeland, Florida, at age eighty-seven. Her second husband, Paul Mowrer, won the Pulitzer Prize for journalism and also wrote poetry every day. He published six books of poetry and was named the first poet laureate of New Hampshire in 1967. Hadley and Paul flew to Idaho almost every year to visit Jack and his family; Hadley was thrilled with her three granddaughters. In April 1971, Hadley and Paul began a trip from Florida to New Hampshire. They stopped at an inn in South Carolina, and Paul "died sitting in a chair sipping a drink." From that time on, Jack, her only child, visited her at least once a year. Hadley broke her hip in 1978, never really recovered and was moved to a nursing home in January 1979. When Jack got a call that she had been rushed to the hospital with internal bleeding, he rushed to Florida and was with her when she died. When Hem and Hadley were divorced in 1927, he made an arrangement with Scribner's for her to receive the royalties from *The Sun Also Rises* (as well as from the film version of the book) for the rest of her life.

Ingrid Bergman died in London of breast cancer on August 29, 1982, her sixty-seventh birthday. In 1950, while still married to Petter Lindstrom, she had a son by Roberto Rossellini (later her second husband). In the midst of the huge scandal that ensued, Hem wrote to her, "I love you very much

and am your same solid friend no matter what you ever do, or decide or where you go." Patricia Neal later said she wished she had had the courage to have her baby, the way Ingrid Bergman did. In 1956, when Ingrid's past was still a matter of considerable controversy in the United States, Ingrid debated whether to travel to New York to receive an award. She was in Paris when she got an unexpected visit from Hem. "Daughter," he said, "I want to come with you to New York and protect you. It's no trouble; I can jump on that plane with you tomorrow morning, I shall be by your side." She graciously declined his offer, saying this was something she had to do "completely alone." Ingrid won Oscars for *Gaslight*, *Anastasia* and *Murder on the Orient Express*. Her daughter Pia Lindstrom and Maria Cooper Janis have been lifelong friends.[176]

Hadley Richardson Hemingway, *left*, and Pauline Pfeiffer, 1925. *Princeton University Library.*

Adriana Ivancich had married a German nobleman by the name of Count Rudolf von Rex in 1963; they had two sons. As Hemingway researcher and author Jobst C. Knigge noted, however, "the memory of Hemingway held her in its grip." In 1965, *Across the River and Into the Trees* was finally published in Italy, and Adriana acknowledged in an interview with an Italian magazine that she indeed had inspired the character of Renata. One year later, she sold all the surviving letters that Hem had written her, several quite intimate. In 1980, Adriana published a memoir about her relationship with Hem called *La Torre Bianca* (*The White Tower*), a reference to the tower at the Finca complex. "In 1980," wrote Bernice Kert, "[Adriana] was my guide through the Venice that she and Ernest inhabited in 1948 and 1949. In a subsequent letter she hinted at various personal problems and in the summer of 1982 she wrote that 'even these few lines are a big effort.' On March 23, 1983, at the age of fifty-three, she committed suicide."[177]

Telly Otto "Toby" Bruce died in Miami on May 9, 1984, at age seventy-three and was buried in the Key West cemetery. Toby and Hem first met in 1928, when Hem and Pauline were in her hometown of Piggot, Arkansas, and Toby, a neighbor of the Pfeiffer family, helped Hem practice

his shotgun shooting by throwing clay pigeons. In 1934, Hem hired "the young cabinetmaker who had built Pauline's furniture, to work for him on a permanent basis, taking over the jobs that Ernest disliked—driver, maintenance man, secretary." Toby became a virtual member of the family and frequently escorted one or more of the boys to or from Sun Valley. He was an honorary pallbearer at Hem's funeral and assisted Mary with Key West business later in 1961.[178]

The month after Toby's death, on June 26, 1984, Carl Foreman died in Los Angeles of a brain tumor at age sixty-nine. Before *High Noon* was even released, he had moved to England, where he lived and worked—and remarried and had children after he and his first wife divorced. Foreman and fellow blacklistee Michael Wilson wrote the screenplay to 1957's *The Bridge on the River Kwai* but were not given credit when the film received the Oscar for best screenplay (along with several other Oscars, including those for best picture and best director). By 1961, with HUAC paranoia fading, Foreman was given full credit for producing and writing *The Guns of Navarone*. The day before Foreman's death, "it was announced that the Academy…trying to make amends for the blacklist, would award Oscars for *Bridge on the River Kwai* to Foreman and Wilson. Their widows picked up their statuettes at a special ceremony."[179]

On Friday, November 28, 1986, the day after Thanksgiving, newspapers across the United States ran AP or UPI stories about Mary Welsh Hemingway, who had succumbed on November 26. Her death at age seventy-eight in New York City's St. Luke's Hospital followed a long illness. The daughter of a lumberman, she was born in Walker, Minnesota, graduated from Northwestern University and became a reporter for the *Chicago Daily News*. She went to London in 1937, later covering World War II for both *TIME* and *LIFE*. She met Hemingway in England in 1944 and married him two years later. "The couple had no children and she left no survivors." A telling detail—or lack of detail—in each story was the failure to mention Jack, Patrick or Gregory. Her "tumultuous" relationship with Hem, to the contrary, was featured in each article. "She said despite many high points in their marriage, there were many low points as well." Hem had called her "useless," had thrown wine in her face and had smashed her typewriter. There was no mention of his saving her life in a Casper, Wyoming hospital. She was to be buried next to her third husband in Ketchum, Idaho.[180]

Nancy "Slim" Gross Hawks Hayward Keith died in a Manhattan hospital of heart failure at age seventy-three on April 6, 1990. She had been twenty-four when Coop gave her away at her first marriage (to Howard Hawks) and

Rocky Cooper, *left*, and Mary Hemingway, shown here in 1959, both lived in New York from the 1960s through the 1980s and maintained their friendship. *Community Library Regional History Department, Ketchum, Idaho, F06350.*

forty-three when her good friend Hem died. The friendship between Hem and Slim, which started in the late 1930s, had weathered a mishap Hem normally would have found unforgivable: on a hunting excursion in 1946, Slim had been careless with a shotgun she thought was unloaded when the gun went off and barely missed Hem. Still, Slim made multiple trips

to the Finca, sometimes with her second husband, Leland Hayward, and sometimes alone. Hem confided to a friend that Slim was one of his "true loves," a sentiment Mary was well aware of. Although Slim insisted that she knew the "women's rules" and always played "from the ladies' tee," Mary was highly suspicious of her and even only half-jokingly threatened to shoot her if she made a play for Hem.[181]

On July 2, 1997, thirty-six years to the day after Hem's death, Jimmy Stewart, the stuttering, aw-shucks actor most similar to Coop, died at age eighty-nine. His wife, Gloria Hatrick McLean, a good friend of Coop and Rocky's before her marriage to Jimmy, had died three years earlier. Gloria and Jimmy's twin daughters, Judy and Kelly, had been born on May 7, 1951, Coop's fiftieth birthday. Jimmy's family was gathered at his bedside when he died, and his last words were reportedly, "I'm going to be with Gloria now."[182]

Martha Gellhorn died in London in 1998 at age eighty-nine. Back in June 1944, a few days after telling Hem their marriage was over, she learned of the D-day crossing at a press conference, while Hem, his *Collier's* press credentials in hand, had earlier been taken with other accredited correspondents to a secret staging area. Marty, however, hitched a ride to the dock, made herself inconspicuous and then stowed away in the latrine of a hospital ship scheduled to cross to Normandy at dawn. After the ship

Hemingway with Slim Hayward (*left*) and Lauren Bacall in Spain, 1959. *Photographer unknown, Papers of Ernest Hemingway, Photograph Collection, John F. Kennedy Presidential Library and Museum, Boston.*

made the crossing, wounded soldiers began arriving via water ambulances, and Marty enlisted several stewards to prepare food for those able to eat, lugged urinals and called for nurses when needed. On the night of June 7, she went ashore to help load wounded men onto stretchers. "So it was that she actually walked on the Normandy beachhead, picking her way through mine fields and barbed wire, while Ernest had been confined to the bridge of a landing craft."[183] Marty showed similar spirit and spunk as she covered wars in Vietnam, the Middle East and Central America. Hem's sons had always loved Marty, and those good feelings continued throughout the years as she saw them occasionally. On the evening of February 14, 1998, suffering from partial blindness and terminal ovarian cancer and with her apartment spotless and her will in order, she put on an audio recording of Sebastian Faulk's *Three Fatal Englishmen*, opened the window slightly, lay down on her bed and swallowed a cyanide pill.[184]

Veronica "Rocky" Balfe Cooper Converse died at the age of eighty-six on February 16, 2000, at her home in Manhattan, almost thirty-nine years after Gary Cooper's death and nineteen years after the death of her second husband, Dr. John Converse, prominent plastic surgeon. She was born in Manhattan and worked briefly as an actress, under the name Sandra Shaw, before marrying Coop on December 15, 1933, at the age of twenty. Rocky took a special interest in Christian service of all kinds, and in the late 1950s, she and Coop joined an organization called Foster Parents Plan for War Children. The Coopers "exchanged letters and financially supported the education and basic necessities of a poverty- and war-devastated" family in Italy by the name of Gravina. When Coop had the chance to make some personal appearances in Italy, he and Rocky and Maria went together and met their "foster daughter," Raffaela, and her mother. Maria wrote that Rocky "had a great knack for putting anybody at ease, in any situation, and she did it here." After Coop's death, when she and Maria were living in New York, Rocky learned of local hospitals that needed volunteer workers. They volunteered at the Institute of Reconstructive Plastic Surgery, with Rocky pushing stretchers and wheelchairs and feeding and talking with patients and Maria helping paralytics gain use of their arms through sketching or painting. Rocky was an active fundraiser for the institute right up to the time of her death.[185]

On January 19, 2005, Tillie Arnold died in Ketchum, Idaho, almost thirty-five years after Lloyd's death. She would have turned one hundred years old on April 6. In 1999, she and coauthor William L. Smallwood had published *Hemingway in Idaho*, the best account of Hemingway's Idaho years.

On March 6, 2005, Teresa Wright, the actress who portrayed Eleanor Gehrig in *The Pride of the Yankees* and won an Oscar for *Mrs. Miniver*, died in New Haven, Connecticut, of a heart attack at age eighty-six. Eleanor Gehrig had died twenty-one years earlier to the day, March 6, 1984, in New York at age seventy-nine, a widow for forty-three years. "Since her husband's death in 1941, Mrs. Gehrig had lived quietly in her apartment on the East Side. She occasionally visited her upstairs neighbor, the late Jack Dempsey, and regularly went to Yankee Stadium with Mrs. Babe Ruth to attend old-timers' games of the World Series."[186]

Patricia Neal died in Edgartown, Massachusetts, of lung cancer on August 8, 2010, at age eighty-four, leaving behind an impressive acting career in films and television and on the stage. In 1951, the same year she broke with Coop, she gave a fine performance in *The Day the Earth Stood Still*—ranked no. 5 on AFI's top ten science fiction list as of 2017. In 1963's *Hud*, she held her own against legends Paul Newman and Melvyn Douglas and won the best actress Oscar. But her affair with Coop also seemed to foreshadow a life of heartbreak. She married Roald Dahl (the same man who had helped Hem get a ride to England in 1944) in 1953, and in December 1960, their four-month-old son, Theo, suffered serious brain damage when a New York taxi struck his stroller, which was being pushed by a nanny. Two years later, Pat and Roald's seven-year-old daughter, Olivia, died of measles encephalitis. In 1965, while pregnant, Pat suffered a series of strokes that left her in a coma. She had to learn to walk and talk again, doing so with the constant assistance of Roald, therapists and friends. In 1983, however, Pat and Roald divorced. Pat discovered he was having an affair with a good friend of the family. In 1978, while doing a film in France, Pat had a chance meeting with Maria Cooper Janis, who greeted her warmly. They saw each other several times and also corresponded. Maria eventually introduced Pat to the nuns at the Benedictine monastery of Regina Landis in Bethlehem, Connecticut. Not only that, but Rocky also invited Pat to lunch in her New York apartment. "Rocky knew about [Roald's affair] and my divorce," wrote Pat. "She was right—we had shared a purgatory. I felt that when she put her arms around me."[187]

In 2011, Paul Hendrickson published *Hemingway's Boat: Everything He Loved in Life and Lost, 1934–1961*, not intended to be a conventional biography, wrote Hendrickson, but "to lock together the words 'Hemingway' and 'boat'" and explore "such ideas as fishing, friendship, and fatherhood, and love of water, and what it means to be masculine in our culture." As far back

as 1987, Hendrickson had tracked down and interviewed Hem's sons—Jack, Patrick and Gregory—and the unconventional biography that resulted, with its "zigzags, and loop-arounds and time-bends and flashbacks and flash-forwards" and with its stream-of-consciousness asides and fine-tuned prose and weaving narrative that feels much more like a novel than a treatise, turned out to be the perfect way to chronicle the wounded lives of Papa, Bumby, Mouse and Gygi.[188]

Just a glance at Hendrickson's index entries for the three sons offers a sort of unconventional bio for each—for Jack (October 10, 1923–December 1,

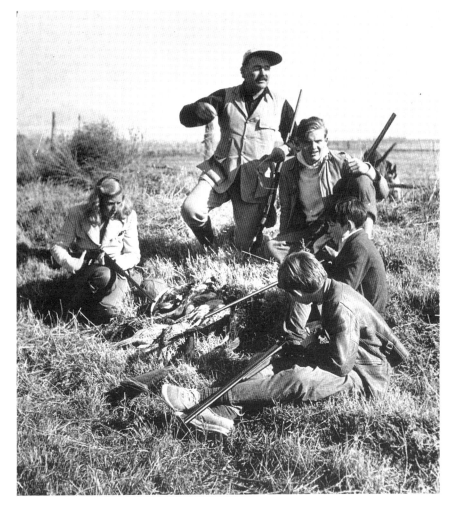

Ernest Hemingway, Martha Gellhorn and Jack, Gregory and Patrick Hemingway hunting, 1941. *Princeton University Library.*

 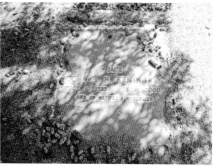

The graves of Gregory and Jack Hemingway, who are buried near their father in the Ketchum, Idaho cemetery. *Photos by the author, 2016.*

2000): "as character in *Islands in the Stream*," "as child in Paris," "fishing by," "laugh of," "in Marine Corps" and "son's death and"; for Patrick (born June 28, 1928): "in Africa," "on bullfighting," "as character in *Islands in the Stream*," "courage of," "fishing by," "hunting by" and "shock treatments received by." But for Gregory, who was born on November 12, 1931, and died on October 1, 2001, fifty years to the day after the death of his mother, Pauline—with Hem and Gregory each blaming the other for Pauline's sudden demise at age fifty-six—the entries are more numerous and much more difficult to fathom: "in Africa," "arrests of," "athletic skill of," "autopsy report of," "cross-dressing of," "death of," "as doctor in Montana," "fishing by," "health problems of," "interest in Dianetics of," "shock treatments received by," "shooting and hunting by," "as transsexual" and "writings of." After Gregory's death in a Miami jail cell, a deputy had to fill out a form listing the clothing and valuables of the deceased. For each item the deputy listed "None."[189]

On December 10, 2016, Bob Dylan's acceptance speech of the Nobel Prize for Literature was read by United States Ambassador to Sweden Azita Raji at the Nobel Banquet. Dylan wrote that from an early age he had read and absorbed the works of previous recipients of the award, identifying six of them by name: Rudyard Kipling, George Bernard Shaw, Thomas Mann, Pearl S. Buck, Albert Camus and Ernest Hemingway. "These giants of literature whose works are taught in the schoolroom, housed in libraries around the world and spoken of in reverent tones have always made a deep impression. That I now join the names on such a list is truly beyond words."[190]

On the morning of Thursday, June 29, 1961, a young Montana literature student by the name of James R. Corey drove east from Missoula to fish for cutthroat trout in a section of the national forest near a mountain known as the Little Hogback. James followed U.S. 12 until reaching the unpaved road that would take him to his angling spot. At the junction of the highway and the gravel road, he saw a gas station and a diner and stopped to fill up his car. After paying for the gas inside the café, he walked outside and saw a late-model Buick with Minnesota plates pull up to the gas pump. A man got out of the driver's side as a woman opened the front passenger door and exited herself. Then the two of them helped a man in the back seat out of the car. James recognized the third man immediately and even had a copy of one of his books—*The Green Hills of Africa*—in his Ford.

James knew what he had to do: get the book out of his car, ask Hemingway to sign it and thank the author for his work. But his plan evaporated as he watched the three people make their way into the café, with Hemingway—the man of men, survivor of world wars, hunter of

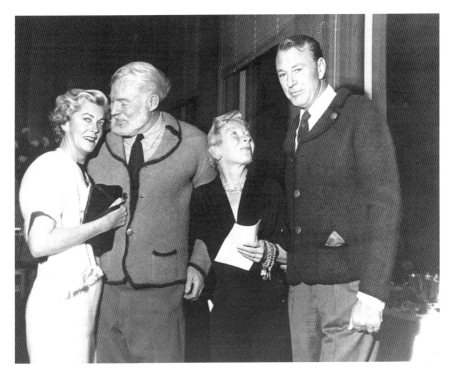

Rocky, Ernest, Mary and Gary in Sun Valley, 1959. *Photographer unknown, Papers of Ernest Hemingway, Photograph Collection, John F. Kennedy Presidential Library and Museum, Boston.*

leopards and lions, fisherman of marlins and swordfish, comrade of Spain's greatest matadors, definer of American maleness—clearly unable to walk on his own. James was certain it was Hemingway but at the same time could not believe it was, not with a frail, almost emaciated body and a timid, vacant expression on his face.

Just as abruptly as he had concluded he had to meet the most famous writer in America, James realized that approaching Hemingway in any way, no matter how respectful, would be cruel and out of the question. Not only that, but the woman James correctly took to be the author's wife was acting so nervous and so protective that she likely would have headed him off before he even got close. So James did the right thing: he respected their privacy and left the mom and pop eatery without saying a word and—as far as he knew—without being noticed.

Still, James was instantly aware that his sighting of the world-renowned author three days before that writer's death had actually involved the union of three of his idols; as he put it, Hemingway "was the creator of my first Montana fictional hero, Robert Jordan of *For Whom the Bell Tolls*, once a language teacher at the University of Montana [and] Robert Jordan had been given film embodiment by my first real-life Montana hero, Gary Cooper."[191]

# NOTES

## Chapter 1

1. Diliberto, *Hadley*, 264; Hawkins, *Unbelievable Happiness*, 221.
2. Diliberto, *Hadley*, 264.
3. Hemingway, *Misadventures of a Fly Fisherman*, 35.
4. Hawkins, *Unbelievable Happiness*, 192–93.
5. Kert, *Hemingway Women*, 343.
6. Letter, Pauline Pfeiffer Hemingway to EH, August 10, 1939, cited in Hawkins, *Unbelievable Happiness*, 221.
7. Ibid., 221–22; letter, EH to Mrs. Paul Pfeiffer, December 12, 1939, cited in Baker, *Hemingway: Selected Letters*, 499.
8. Hemingway, *Misadventures of a Fly Fisherman*, 36; Kert, *Hemingway Women*, 329.
9. *PR*, September 26, 1939.
10. Arnold, *Hemingway*, 1.
11. Arnold, *Idaho Hemingway*, 21; Arnold, *Hemingway*, 12.
12. Arnold, *Hemingway*, 4.
13. Arnold, *Idaho Hemingway*, 32, 47. In chapter 13 of *For Whom the Bell Tolls*, contemplating a future life with Maria, Robert Jordan imagines how the two of them might be known as Mr. and Mrs. Robert Jordan and live in a place like Sun Valley, Idaho; Corpus Christi, Texas; or Butte, Montana. Hemingway, *For Whom the Bell Tolls*, 164.

14. Dardis, *Thirsty Muse*, 158, 178. In Spain in the fall of 1937, Hemingway's drinking was so excessive that he suffered a sudden liver attack that required drugs prescribed for incipient cirrhosis. Ibid., 176.
15. *PR*, October 2, 1939.
16. Arnold, *Hemingway*, 25.
17. Meyers, *Gary Cooper*, 139.
18. Arnold, *Idaho Hemingway*, 61.
19. Ibid., 62–63; Arnold, *Hemingway*, 26–28.
20. *OT*, October 30, 1939. Lloyd Arnold's account, though somewhat ambiguous, indicates that Gene and Dave both fired one shot initially but that the recoil from Gene's shot knocked him into Dave's line of fire and that Dave's second—and intentional—shot struck Gene. Arnold, *Hemingway*, 26–27. The AP story, by contrast, implies that the fatal shot was accidental. Further, Tillie Arnold wrote that only two shots were fired: Gene's, followed by Dave's fatal—and intentional—shot. Arnold, *Idaho Hemingway*, 62. In his book, Lloyd did not identify Dave Benner by name, instead giving him the pseudonym of "Dee." Tillie, presumably writing after Dave Benner's death, did identify him.
21. Percy Hutchison, "Love and War in the Pages of Mr. Hemingway," *NYT*, September 29, 1929.
22. *IS*, "Eulogy to Gene Van Guilder," November 2, 1939.
23. Arnold, *Idaho Hemingway*, 62–69; Arnold, *Hemingway*, 28–30. Lloyd and Tillie's recollections of the series of events that followed Gene's death are not always consistent. This narrative largely follows Tillie's account.
24. Arnold, *Idaho Hemingway*, 76.
25. EH to Maxwell Perkins, December 8, 1939, cited in Baker, *Hemingway: Selected Letters*, 498.
26. EH to Mrs. Paul Pfeiffer, December 12, 1939, cited in Baker, *Hemingway: Selected Letters*, 499–500.
27. May Pfeiffer to EH, n.d., Princeton University Special Collections, cited in Hawkins, *Unbelievable Happiness*, 223.
28. Arnold, *Idaho Hemingway*, 77–78; Arnold, *Hemingway*, 30–31.

## *Chapter 2*

29. Arnold, *Hemingway*, 40–43.
30. Letter, EH to Maxwell Perkins, circa October 12, 1940, cited in Baker, *Hemingway: Selected Letters*, 518.

31. Meyers, *Gary Cooper*, 202; Baker, *Hemingway: A Life Story*, 231.

32. Arnold, *Idaho Hemingway*, 75; Dardis, *Thirsty Muse*, 167.

33. Swindell, *Last Hero*, 148. Cooper's good friends knew that he was much better informed than he let on. Joel McCrea, for example, remembered a time in the early 1930s when Coop "launched into as intelligent a discussion of international affairs as I have ever heard. He knew everything that had happened—names, places, dates and facts." Meyers, *Gary Cooper*, 81.

34. Donald Ogden Stewart, "An Interview," *Fitzgerald-Hemingway Annual*, 1973, 85, cited in Meyers, *Hemingway*, 171. Meyers also pointed out, however, that Hemingway never quarreled with either James Joyce or Ezra Pound. Indeed, Pound said near the end of his life, "Hemingway did not disappoint me.…I never saw him save at his best." Meyers, *Hemingway*, 75.

35. Wayne, *Cooper's Women*, 90.

36. Ibid., 54.

37. Hemingway, *Papa*, 44.

38. Arnold, *Hemingway*, 40–46; Arnold, *Idaho Hemingway*, 90–92.

39. Letter, EH to Maxwell Perkins, circa October 12, 1940, cited in Baker, *Hemingway: Selected Letters*, 518.

40. Meyers, *Gary Cooper*, 176–77. Tillie mistakenly dates the arrival of the advance copies to October 22.

41. Swindell, *Last Hero*, 223. Hemingway based the character of Robert Jordan partly on Major Robert Hale Merriman, who became the highest-ranking American in the Lincoln Brigade. Hemingway and Martha Gellhorn met Merriman, and both were favorably impressed. "He explained the offensive to us, drawing the plan of it on the dirt of the floor," wrote Martha, "going over every point carefully as if we were his freshman class in economics back in California.…We knew that he had led the assault on Belchite, and that he was wounded six times by fragments from hand grenades, and that he would not stop to be bandaged until the fighting was over.…I thought: I'm proud as a goat that the Americans are known in Spain as good men and fine soldiers. That's all there is to it: I'm proud." Like Gary Cooper, Merriman was known for his quiet manner. In April 1938, Merriman led 450 other Americans who were part of a Republican force overwhelmed by Nationalists. Merriman was never seen again. "His death occurred offstage," wrote Cecil D. Eby, "and by implication, as does the death of Robert Jordan in *For Whom the Bell Tolls*." Cecil D. Eby, "The Real Robert Jordan," *American Literature* 38, no. 3 (1966): 382, 384.

42. Cited in Mulholland, *Cooper & Hemingway*.

43. Janis, *Gary Cooper Off Camera*, 99.

44. *NYT*, October 21, 1940; *Saturday Review of Literature*, October 26, 1940. There were detractors, however. "I was disappointed," said Albert Camus, "that [Hemingway] chose to stick an MGM-style love story into the middle of the prodigious events that took place in Spain." Chamberlin, *Hemingway Log*, 223n634.

45. Cited in Mulholland, *Cooper & Hemingway*.

46. Ibid.

47. Meyers, *Gary Cooper*, 175.

48. Arce, *Gary Cooper*, 171.

49. Meyers, *Gary Cooper*, 152.

50. Baker, *Hemingway: A Life Story*, 355; Hutchisson, *Ernest Hemingway*, 178.

51. Meyers, *Hemingway*, 159.

52. Hutchisson, *Ernest Hemingway*, 53; Baker, *Hemingway: A Life Story*, 120.

53. Letter, EH to Solita Solano, January 26, 1941, cited in Baker, *Hemingway: Selected Letters*, 522.

54. Bergman and Burgess, *My Story*, 97–98, 100.

55. Chamberlin, *Hemingway Log*, 227.

56. Arce, *Gary Cooper*, 173.

57. Meyers, *Gary Cooper*, 151–52; Arce, *Gary Cooper*, 175.

58. *Time*, March 3, 1941.

59. Meyers, *Gary Cooper*, 156–57; American Film Institute, http://www.afi.com/members/catalog/DetailView.aspx?s=&Movie=27041, accessed on November 28, 2016.

60. Arnold, *Idaho Hemingway*, 106.

61. Hutchisson, *Ernest Hemingway*, 178–80.

62. Letter, EH to Prudencio de Pereda, August 14, 1941, cited in Baker, *Hemingway: Selected Letters*, 526.

63. Keith, *Slim*, 43–44.

64. Letter, EH to Maxwell Perkins, November 15, 1941, cited in Baker, *Hemingway: Selected Letters*, 527; Chamberlin, *Hemingway Log*, 234. Hem added, with good humor, that Coop was pretty tight with money.

65. Hemingway memorialized this experience in a 1951 short story called "The Shot."

66. Arnold, *Idaho Hemingway*, 121–22; Hemingway, *Life Worth Living*, 62.

67. Arnold, *Idaho Hemingway*, 107.

68. Ibid., 116.

69. Ibid., 107.

70. Hemingway, *Papa*, 44–45.

71. Hendrickson, *Hemingway's Boat*, 383–84.

72. Letter, EH to Pauline Hemingway, June 9, 1941, cited in Baker, *Hemingway: Selected Letters*, 524; Hendrickson, *Hemingway's Boat*, 391, 392n.

73. *PR*, November 21, 1941; November 28, 1941.

74. Arnold, *Idaho Hemingway*, 123.

75. Gellhorn, *Face of War*. Bernice Kert wrote that this incident took place in Tucson, Arizona. Kert, *Hemingway Women*, 365.

76. Letter, EH to Maxwell Perkins, December 11, 1941, cited in Baker, *Hemingway: Selected Letters*, 531.

77. Meyers, *Gary Cooper*, 167.

## Chapter 3

78. Letter, EH to Patrick Hemingway, October 7, 1942, cited in Baker, *Hemingway: Selected Letters*, 543.

79. Bergman and Burgess, *My Story*, 117–22.

80. *DH*, January 7, 1944.

81. Swindell, *Last Hero*, 250; Arce, *Gary Cooper*, 189; Meyers, *Gary Cooper*, 169.

82. Meyers, *Gary Cooper*, 169.

83. Janis, *Gary Cooper Off Camera*, 54.

84. Swindell, *Last Hero*, 250–51.

85. Letter, GC to EH, May 1, 1945, JFK.

86. Kert, *Hemingway Women*, 367.

87. Keith, *Slim*, 72.

88. Hutchisson, *Ernest Hemingway*, 181.

89. Kert, *Hemingway Women*, 381.

90. Ibid., 388.

91. Ibid., 391–92.

92. Ibid., 392.

93. Hemingway, *How It Was*, 117.

## Chapter 4

94. Letter, EH to Colonel Charles T. Lanham, April 2, 1945, cited in Baker, *Hemingway: Selected Letters*, 579; letter, EH to Mary Welsh, April 9, 1945, ibid., 582.

95. Letter, EH to General Charles T. Lanham, August 25, 1946, cited in Baker, *Hemingway: Selected Letters*, 609–10.

96. Arnold, *Idaho Hemingway*, 134–41.

97. Meyers, *Gary Cooper*, 208.

98. Gary Cooper: Excerpts of Testimony before HUAC, https://pages.shanti.virginia.edu/Wild_Wild_Cold_War/files/2011/11/GaryCooperHUAC.pdf, accessed on January 14, 2017.

99. *SCS*, October 23, 1947; *HS*, October 24, 1947.

100. Cited in Byman, *Showdown at High Noon*, 59.

101. Kaminsky, *Coop*, 5.

102. Hem was particularly upbeat about this time because producer Mark Hellinger had offered him $50,000 per year for four unwritten short stories, plus 10 percent of the film profits. Hem still had a $20,000 advance—in the form of a check—when word came that Hellinger had died. The deal was off, and Hem returned the check to Hellinger's widow. Reynolds, *Hemingway*, 154, 162.

## Chapter 5

103. Shearer, *Patricia Neal*, 56–57; Neal, *As I Am*, 100–101.

104. Kert, *Hemingway Women*, 439; Reynolds, *Hemingway*, 186.

105. Swindell, *Last Hero*, 250.

106. Neal, *As I Am*, 103.

107. Kert, *Hemingway Women*, 441.

108. Neal, *As I Am*, 102–5.

109. Kert, *Hemingway Women*, 442–43.

110. Neal, *As I Am*, 115–16.

111. Ibid., 121–24.

112. Kert, *Hemingway Women*, 450–51.

113. Hutchisson, *Ernest Hemingway*, 212.

114. Neal, *As I Am*, 133–34.

115. Hutchisson, *Ernest Hemingway*, 212–13; Kert, *Hemingway Women*, 459–60.

116. Neal, *As I Am*, 134–42.

## Chapter 6

117. Cited in Mulholland, *Cooper & Hemingway*.

118. Baker, *Hemingway: A Life Story*, 519–22.

119. Byman, *Showdown at High Noon*, 79, 78, 77.

120. For more than thirty years, Coop dealt with the pressures of being one of the best-known celebrities in the world, with a multitude of fans hoping to just get a glimpse of him. Throughout it all, he treated those fans well. One example: "One fall evening in the late 1950s, in Burns, Oregon, five teenagers were out 'dragging main street'—Marcheta Russell and her best friend Wilma Sherman, Linda Johnson and her best friend Bobbie Russell, and tag-along Lane Johnson. As we were cruising by a popular restaurant called the Pine Room, to our amazement we spotted who we thought was Gary Cooper going inside. We could hardly believe our eyes—a famous movie star actually in our town? We decided to make sure, so we parked the car and eased in to where we could peek into the restaurant. Sure enough, there he sat with the Ansel Marshall family, who had a ranch north of Burns. Gary visited them often to go hunting. Seeing ten curious eyes peering at him around the corner, he smiled and told us to come on over. He was so kind to us. He had on a leather jacket, and his cowboy hat was hanging on the back of the booth. His skin looked tan and leathery like his jacket. Lane produced paper and a ball-point pen, and he gave us each an autograph. He mentioned how unusual the pen was—yellow and three-sided—and Lane said, 'Please keep it!' which he did with many thanks. We left then, and still could hardly believe our luck at actually meeting this kind and gracious movie star." From Linda Salsbery, October 2016.
121. Janis, *Gary Cooper Off Camera*, 171.
122. Mary Claire Kendall, "Gary Cooper's Quiet Journey of Faith," Forbes website, http://www.forbes.com/sites/maryclairekendall/2013/05/13/gary-coopers-quiet-journey-of-faith/#15a5a09a8a56, accessed on January 19, 2017. A.E. Hotchner wrote that Coop told Hotchner and Hem—apparently in January 1959—that "he had finally converted to Catholicism to please his wife, Rocky, and his daughter, Maria." Hotchner, *Papa Hemingway*, 202. Later in his memoir, however (as discussed in chapter 7), Hotchner added that when he visited Coop shortly before his death, Coop made him promise to tell Hem, essentially as Coop's dying words, that his deciding to convert was the best thing he ever did. Ibid., 290.
123. Chamberlin, *Hemingway Log*, 295.
124. Letter, GC to EH, March 5, 1956, JFK; letter, EH to GC, March 9, 1956, cited in Baker, *Hemingway: Selected Letters*, 855–57.
125. Reynolds, *Hemingway*, 298–99.
126. Janis, *Gary Cooper Off Camera*, 115–17.
127. Meyers, *Gary Cooper*, 295; Johnson, *Man Who Shot Liberty Valance*, 214.

128. Arnold, *Idaho Hemingway*, 195–98.

129. Chamberlin, *Hemingway Log*, 312–15.

130. Arnold, *Idaho Hemingway*, 199–203.

131. Hutchisson, *Ernest Hemingway*, 242, 244.

132. Hemingway, *Running with the Bulls*, 124.

133. Letter, GC to Ernest and Mary Hemingway, May 2, 1960, JFK.

134. Arnold, *Hemingway*, 318–20.

135. Janis, *Gary Cooper Off Camera*, 164.

## *Chapter 7*

136. Hector Arce wrote that the Coopers watched the telecast with Coop's agent, Charles Feldman, and Sam and Frances Goldwyn. *Gary Cooper*, 10.

137. From YouTube, https://www.youtube.com/watch?v=qYU8EtD9jPM&t=73s, accessed on January 4, 2017.

138. Arnold, *Idaho Hemingway*, 226.

139. *SLT*, July 3, 1961. In her 1999 memoir, Tillie wrote that she was mystified by Hem's biographers claiming that Coop said he would beat Hem to the barn. "He could not have said anything like that without Papa saying something in return," she argued. Arnold, *Idaho Hemingway*, 226. The Associated Press interview with Rocky, however, was conducted on July 2, 1961, and opened with this lead: "'They're both in the barn now,' Mrs. Gary Cooper said Sunday night of the death of Ernest Hemingway." The piece next described how Hemingway was watching the Academy Awards on April 17 and called Cooper afterward. Mulholland, *Cooper & Hemingway*, reports that Cooper's statement about beating Hemingway to the barn was actually made on March 26, 1961, when the two talked by phone after the telecast of *The Real West* but does not provide the source of that information.

140. Meyers, *Gary Cooper*, 310.

141. Cooper, "How I Faced Tomorrow," 166; Janis, *Gary Cooper Off Camera*, 165; Meyers, *Gary Cooper*, 313.

142. Munn, *Jimmy Stewart*, Kindle edition.

143. *Life*, "Sad News of Cooper," April 28, 1961, 74A.

144. Janis, *Gary Cooper Off Camera*, 165.

145. Swindell, *Last Hero*, 303; Meyers, *Gary Cooper*, 313–14.

146. Meyers wrote that "when [Hemingway] telephoned the actor from the Mayo in May 1961, Cooper said: 'I bet I make it to the barn before you

do.'" *Hemingway*, 559. Reynolds repeated this claim and cited Meyers as his source. (*Hemingway*, 365.) Meyers's citing Hotchner's *Papa Hemingway* as his source, however, clearly involves a misreading of Hotchner. "The first week in May [1961]," wrote Hotchner, "I went to see Cooper for the last time." During that conversation, Coop said, "Papa phoned a couple weeks ago.…I bet him that I will beat him out to the barn." (*Papa Hemingway*, 289.) Note that according to Hotchner, Coop did not say that Hem called him from the Mayo nor that Hem called him in May. Hotchner himself makes it reasonably clear that when Coop said Hem "phoned a couple weeks ago," he is referring to the phone call between him and Hem that took place the night of the Academy Awards—two weeks and two days before Hotchner and Coop talked on May 3. As noted, there is no evidence that Hem and Coop talked at any point after the Oscar night of April 17.

147. Hotchner, *Papa Hemingway*, 289–90.

148. Meyers, *Gary Cooper*, 191; Arce, *Gary Cooper*, 278.

149. Cooper, "How I Faced Tomorrow," 166.

150. *ST*, May 14, 1961. Coop died on Saturday, May 13, 1961.

## *Chapter 8*

151. Reynolds, *Hemingway*, 353–54.

152. Arnold, *Idaho Hemingway*, 227.

153. Letter, EH to Charles Scribner Jr., April 18, 1961, Princeton University Special Collections, cited in Reynolds, *Hemingway*, 354; letter, Mary Welsh Hemingway to Ursula Hemingway Jepson, April 25, 1961, JFK, cited in Reynolds, *Hemingway*, 354; Hemingway, *How It Was*, 630.

154. Hemingway, *How It Was*, 631.

155. Baker, *Hemingway: A Life Story*, 561.

156. *PT*, April 26, 1961.

157. JFK.

158. Hemingway, *How It Was*, 633.

159. Ibid.

160. Diliberto, *Hadley*, 276–77.

161. Hemingway, *How It Was*, 632–33.

162. Hotchner, *Papa Hemingway*, 295–300.

163. The 100th meridian runs through North Dakota, South Dakota, Nebraska, Kansas, Oklahoma and Texas.

164. Hemingway, *How It Was*, 634–35.

165. Moulton, *Journals of the Lewis & Clark Expedition*, 187.

166. This version of Chief Joseph's speech was abbreviated but accurately quoted.

167. Hemingway, *How It Was*, 635.

168. Arnold, *Idaho Hemingway*, 227.

169. Hemingway, *How It Was*, 635–36.

## *Chapter 9*

170. Bittner, "Dateline Sun Valley," 241–56, cited by the Free Library website, https://www.thefreelibrary.com/ ors+serie,+fin+dramatique%3 A+the+Paris+press+ coverage+of+the+death...-a0132418679, accessed on November 5, 2016.

171. *NYT*, July 2, 1961.

172. *SBDS*, July 3, 1961.

173. Letter, EH to Frederick G. Saviers, June 15, 1961, cited in Baker, *Hemingway: Selected Letters*, 921. Fritz died on March 11, 1967.

174. *IR*, October 8, 1967; Janis, *Gary Cooper Off Camera*, 75.

175. *SBDS*, September 23, 1974.

176. Bergman and Burgess, *My Story*, 240, 339.

177. Jobst C. Knigge, "Hemingway's Venetian Muse Adriana Ivancich," 75, Humboldt University Berlin, 2011, http://edoc.hu-berlin.de/oa/ reports/reeXmGuxoJO2/PDF/257OuZ2UGqA.pdf, accessed on January 3, 2017; Kert, *Hemingway Women*, 13.

178. Chamberlin, *Hemingway Log*, 91, 327, 337; Kert, *Hemingway Women*, 265.

179. Byman, *Showdown at High Noon*, 91.

180. *SCS*, November 28, 1986 (AP); *PT*, November 28, 1986 (UPI).

181. Meyers, *Hemingway*, 424; Reynolds, *Hemingway*, 260, 290.

182. Classic Cinema Gold, http://classiccinemagold.com/category/james-stewart, accessed on January 1, 2017.

183. Kert, *Hemingway Women*, 405–6.

184. Moorehead, *Gellhorn*, 423–24.

185. Janis, *Gary Cooper Off Camera*, 84; Cooper, "How I Faced Tomorrow," 160, 166; *NYT*, March 7, 2000.

186. *IJ*, March 9, 2005; *NYT*, March 8, 1984.

187. Neal, *As I Am*, 370.

188. Hendrickson, *Hemingway's Boat*, 14, 13.

189. Ibid., 520–21, 451.

190. The official website of the Nobel Prize, https://www.nobelprize.org/ nobel_prizes/literature/laureates/2016/dylan-speech.html, accessed on December 31, 2016.

191. James R. Corey, "An Encounter with Hemingway," *Hemingway Review* 12, no. 1 (Fall 1992): 77–79.

# BIBLIOGRAPHY

## Manuscript Sources and Archives

Gallatin History Museum, Bozeman, Montana (GHM).
John F. Kennedy Presidential Library and Museum, Boston (JFK).
Montana Historical Society, Helena (MHS).
Princeton University Special Collections, Princeton, New Jersey (PUSC).

## Books and Articles

Arce, Hector. *Gary Cooper: An Intimate Biography*. New York: William Morrow and Company, 1979.

Arnold, Lloyd. *Hemingway: High on the Wild*. New York: Grosset & Dunlap, 1968.

Arnold, Tillie, with William L. Smallwood. *The Idaho Hemingway*. Buhl, ID: Beacon Books, 1999.

Baker, Carlos. *Ernest Hemingway: A Life Story*. New York: Charles Scribner's Sons, 1969.

Baker, Carlos, ed. *Ernest Hemingway: Selected Letters*. New York: Charles Scribner's Sons, 1981.

Bellavance-Johnson, Marsha. *Ernest Hemingway in Idaho: A Guide*. Ketchum, ID: Computer Lab, 1997.

Bergman, Ingrid, and Alan Burgess. *My Story*. New York: Delacorte Press, 1980.

Bittner, John. "Dateline Sun Valley: The Press Coverage of the Death of Ernest Hemingway." In *Hemingway and the Natural World*. Edited by Robert E. Fleming. Moscow: University of Idaho Press, 1999.

Blume, Lesley M.M. *Everybody Behaves Badly: The True Story Behind Hemingway's Masterpiece* The Sun Also Rises. Boston: Houghton Mifflin Harcourt, 2016.

Bruccoli, Matthew J. *The Only Thing that Counts: The Ernest Hemingway–Maxwell Perkins Correspondence*. Columbia: University of South Carolina Press, 1996.

Bruccoli, Matthew J., ed. *Conversations with Ernest Hemingway*. Jackson: University Press of Mississippi, 1986.

Burwell, Rose Marie. *Hemingway: The Postwar Years and the Posthumous Novels*. Cambridge, UK: Cambridge University Press, 1996.

Byman, Jeremy. *Showdown at High Noon: Witch-Hunts, Critics, and the End of the Western*. Lanham, MD: Scarecrow Press, 2004.

Chamberlin, Brewster. *The Hemingway Log: A Chronology of His Life and Times*. Lawrence: University Press of Kansas, 2015.

Cooper, Mrs. Gary, as told to George Christy. "How I Faced Tomorrow." *Good Housekeeping*, September 1963, 81–83, 160–68.

Dardis, Tom. *The Thirsty Muse: Alcohol and the American Writer*. New York: Ticknor & Fields, 1989.

DeFazio, Albert J., III. *Dear Papa, Dear Hotch: The Correspondence of Ernest Hemingway and A.E. Hotchner.* Columbia: University of Missouri Press, 2005.

Diliberto, Gioia. *Hadley*. New York: Ticknor & Fields, 1992.

Gellhorn, Martha. *The Face of War*. New York: Atlantic Monthly Press, 1994.

———. *Travels with Myself and Another: A Memoir*. New York: Jeremy P. Tarcher/Putnam, 2001.

Graham, Sheilah, and Gerold Frank. *Beloved Infidel: The Education of a Woman*. New York: Henry Holt and Company, 1958.

Hawkins, Ruth A. *Unbelievable Happiness and Final Sorrow: The Hemingway-Pfeiffer Marriage*. Fayetteville: University of Arkansas Press, 2012.

Hemingway, Ernest. *For Whom the Bell Tolls*. New York: Scribner, 2003.

———. *A Moveable Feast*. Restored edition. New York: Scribner, 2009.

Hemingway, Gregory H. *Papa: A Personal Memoir*. Boston: Houghton Mifflin Company, 1976.

Hemingway, Jack. *A Life Worth Living: The Adventures of a Passionate Sportsman*. Guilford, CT: Lyons Press, 2002.

———. *Misadventures of a Fly Fisherman*. Dallas, TX: Taylor Publishing Company, 1986.

Hemingway, John. *Strange Tribe: A Family Memoir*. Guilford, CT: Lyons Press, 2007.

Hemingway, Mariel. *Out Came the Sun: Overcoming the Legacy of Mental Illness, Addiction, and Suicide in My Family*. New York: Regan Arts, 2015.

Hemingway, Mary Welsh. *How It Was*. New York: Ballantine Books, 1977.

Hemingway, Valerie. *Running with the Bulls: My Years with the Hemingways*. New York: Ballantine Books, 2004.

Hendrickson, Paul. *Hemingway's Boat: Everything He Loved in Life and Lost, 1934–1961*. New York: Alfred A. Knopf, 2011.

Heston, Charlton. *The Actor's Life: Journals, 1956–1976*. New York: E.P. Dutton, 1976, 1978.

Hotchner, A.E. *Papa Hemingway: A Personal Memoir*. New York: Random House, 1966.

Hutchisson, James M. *Ernest Hemingway: A New Life*. University Park: Pennsylvania State University Press, 2016.

Janis, Byron, with Maria Cooper Janis. *Chopin and Beyond: My Extraordinary Life in Music and the Paranormal*. Hoboken, NJ: John Wiley & Sons, 2010.

Janis, Maria Cooper. *Gary Cooper Off Camera: A Daughter Remembers*. New York: Harry N. Abrams Inc., Publishers, 1999.

Johnson, Dorothy M. *The Man Who Shot Liberty Valance (and Other Stories)*. Helena, MT: Riverbend Publishing, 2005.

Kaminsky, Stuart M. *Coop: The Life and Legend of Gary Cooper*. New York: St. Martin's Press, 1980.

Keith, Slim, with Annette Tapert. *Slim: Memories of a Rich and Imperfect Life*. New York: Simon and Schuster, 1990.

Kert, Bernice. *The Hemingway Women*. New York: W.W. Norton & Company, 1983.

Laurence, Frank M. *Hemingway and the Movies*. New York: Da Capo Press, 1981.

Lynn, Kenneth S. *Hemingway*. Cambridge, MA: Harvard University Press, 1987.

Mellow, James R. *Hemingway: A Life without Consequences*. New York: Da Capo Press, 1992.

Meyers, Jeffrey. *Gary Cooper: American Hero*. New York: Cooper Square Press, 2001.

———. *Hemingway: A Biography*. New York: Da Capo Press, 1985.

Moorehead, Caroline. *Gellhorn: A Twentieth-Century Life*. New York: Henry Holt and Company, 2003.

Moulton, Gary E. *The Journals of the Lewis & Clark Expedition*. Vol. 5. Lincoln: University of Nebraska Press, 1988.

Neal, Patricia. *As I Am: An Autobiography*. New York: Simon and Schuster, 1988.

Oliver, Charles M. *Ernest Hemingway A to Z: The Essential Reference to the Life and Works*. New York: Facts on File, 1999.

Reynolds, Michael. *Hemingway: The Final Years*. New York: W.W. Norton & Company, 1999.

Shearer, Stephen Michael. *Patricia Neal: An Unquiet Life*. Lexington: University of Kentucky Press, 2006.

Swindell, Larry. *The Last Hero: A Biography of Gary Cooper*. New York: Doubleday & Company, 1980.

Thomson, David. *Gary Cooper*. New York: Faber and Faber, 2009.

Trogdon, Robert W., ed. *Ernest Hemingway: A Literary Reference*. New York: Carrroll & Graf Publishers, 1999.

Wayne, Jane Ellen. *Cooper's Women*. New York: Prentice Hall Press, 1988.

## *Newspapers*

*Daily Herald* (*DH*), Chicago, Illinois.

*Gazette and Daily* (*GD*), York, Pennsylvania.

*Hope Star* (*HS*), Hope, Arkansas.

*Idaho State Journal,* (*ISJ*), Pocatello, Idaho.

*Idaho Statesman* (*IS*), Boise, Idaho.

*Independent Record* (IR), Helena, Montana.

*Index-Journal* (*IJ*), Greenwood, South Carolina.

*New York Times* (*NYT*), New York City.

*Oakland Tribune* (*OT*), Oakland, California.

*Pharos Tribune* (*PT*), Logansport, Indiana.

*Post Register* (*PR*), Idaho Falls, Idaho.

*Salt Lake Tribune* (*SLT*), Salt Lake City, Utah.

*San Bernardino Daily Sun* (*SBDS*), San Bernardino, California.

*Santa Cruz Sentinel* (*SCS*), Santa Cruz, California.

*Sun Telegram* (*ST*), San Bernardino, California.

## *DVD*

Mulholland, John, writer and director. *Cooper & Hemingway: The True Gen*. New York: Passion River, 2015.

# INDEX

# ABOUT THE AUTHOR

Larry E. Morris is the author of *The 1959 Yellowstone Earthquake*, published in 2016 by The History Press. An independent writer and historian, Larry was born and raised in Idaho Falls, Idaho, and received degrees in American literature and philosophy from Brigham Young University. He is the author of *The Fate of the Corps: What Became of the Lewis and Clark Explorers After the Expedition* and *The Perilous West: Seven Amazing Explorers and the Founding of the Oregon Trail* and co-author, with Ronald M. Anglin, of *The Mystery of John Colter: The Man Who Discovered Yellowstone*. Larry has also published articles on western history in such periodicals as *American History*, the *Missouri Historical Review*, the *Rocky Mountain Fur Trade Journal* and *St. Louis* magazine.

Larry has spoken at a national meeting of the Lewis and Clark Trail Heritage Foundation, the Montana Historical Society and the Salt Lake City Book Festival and at events in Washington, Oregon, Idaho and Wyoming. He is a contributor to the Oregon Encyclopedia (http://www.oregonencyclopedia.org).

Larry and his wife, Deborah, have four children and eight grandchildren and live in Salt Lake City, Utah.

*Visit us at*
www.historypress.net
..........................................................
*This title is also available as an e-book*